Brancusi/The Kiss

Brancusi/The Kiss

Sidney Geist

Icon Editions
HARPER & ROW, PUBLISHERS
New York, Hagerstown, San Francisco, London

FIRST EDITION

Designed by C. Linda Dingler

Library of Congress Cataloging in Publication Data

Geist, Sidney.
 Brancusi/The kiss.
 (Icon editions)
 Includes bibliographical references and index.
 1. Brâncusi, Constantin, 1876–1957. The kiss.
I. Title.
NB933.B7G39 1978 730'.92'4 76-27502
ISBN 0-06-433257-8
ISBN 0-06-430081-1 pbk.

78 79 80 81 82 10 9 8 7 6 5 4 3 2 1

Contents

Acknowledgments

The suggestion that I write this study first came from Albert Elsen, Stanford University, who then set the project on its way by making available to me a group of photographs of late nineteenth and early twentieth century sculpture, many of which appear in this book; I am most grateful for his help and interest. I have benefitted also from the advice of Lydia Gasman, New York, and have received assistance of different kinds from Pierre Coulomb, director of the Service Culturel, Neuilly-sur-Seine; Angelika Arnoldi, Munich; Aracy Amaral, São Paulo; Dr. Pascu Atanasiu and Stanislas Lélio, Paris; Daniel Rosenfeld, Boston; and Steven Sloman and Marvin Torffield, New York. My thanks go too to the many private persons and public institutions whose collections include the works here reproduced. In this respect I express my special gratitude for her help to Marielle Tabart, Musée National d'Art Moderne, Centre Georges Pompidou, Paris.

SG
New York

Brancusi/The Kiss

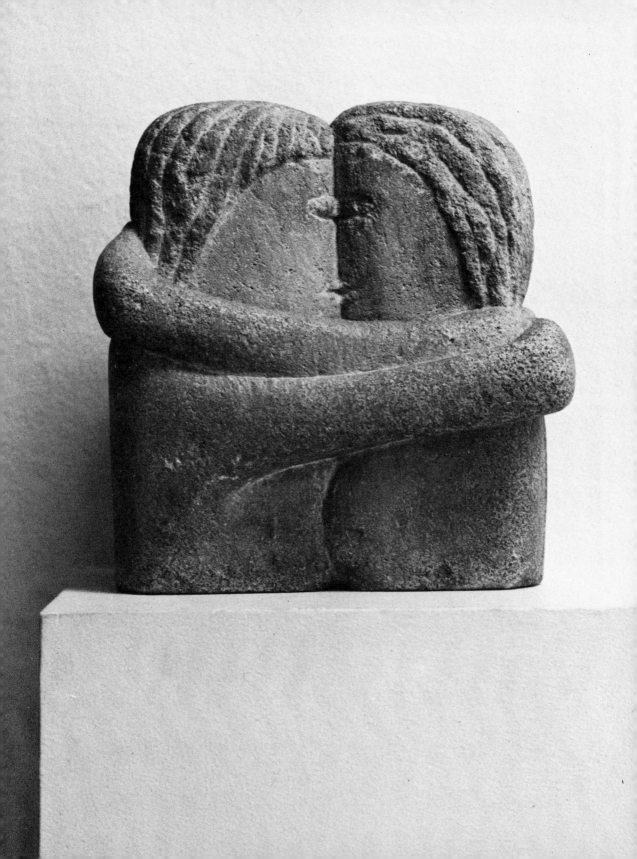

Theme

With the carving of *The Kiss* [1], Brancusi, by a supreme effort of will, intelligence, and imagination, leaps out of his past. Nothing, or very little, in his earlier work prepares us for it, for its special poetry, its unobtrusive, densely packed invention. Placed against everything that precedes it, *The Kiss* gives the impression of issuing from a new hand; one writer has said that it "seemed to arrive 'from nowhere'."[1] And efforts to account for it, to situate it in time and within Brancusi's developing art, have been few enough in spite of the fact that it is the cornerstone of a great modern oeuvre.[2]

But it appears that by examination of the biographical record, of the object itself, and of the artistic and social background, by a revision—as seems necessary—of our understanding of a certain artistic evolution in the first decade of this century, and with the help of a hypothesis—irresistibly attractive, simple, and of great explanatory power—it is possible to reconstitute the forces which converged on the creation of *The Kiss*. Before pursuing this purpose we shall bring the sculptor's biography to the threshold of *The Kiss*, examine the key term—*la taille directe*—in any discussion of the work, and glance at some aspects of the Kiss in art, which, even

1

1. *The Kiss*, 1907–08.

when they do not directly influence Brancusi, nevertheless illuminate his peculiar achievement.

After walking most of the way across Europe, Brancusi arrived in Paris, probably in the early summer of 1904, in weakened health and out of funds. Never physically robust, he had fallen ill in eastern France after being caught in a rainstorm, and had written to a friend in Paris for money to make the last leg of his journey by train. He was twenty-eight years old. Among the belongings in his knapsack were a few photographs of work done in Rumania and a diploma from the Bucharest School of Fine Arts.

Between his arrival in Paris and the making of *The Kiss* three and a half years later—after recovering his strength, adjusting to his new surroundings, and in spite of time spent at the menial jobs by which he earned his living— he did some fifty pieces of which we have knowledge, in many cases only by photographs, besides an unknown number of studies from life done in the more than year and a half of his attendance at the Ecole des Beaux Arts. These pieces range from bibelots to the life-size *The Prayer;* they are in relief and in the round, in plaster and, in a few cases, bronze, and they include seven carvings in stone and marble.

Brancusi's journey to Paris and his industriousness there, against all odds, show him to have been possessed by a fierce will and a burning ambition—a point that must be emphasized in view of the figure of patriarchal calm and wisdom he presented to the world in his last years. The bearded sculptor has been variously described as an oriental sage, a benign Carpathian peasant, and the Saint of Montparnasse for so long a time that it requires an effort to realize that the boy who ran away from the hamlet of Hobița, who managed to get an education in Craiova and Bucharest, and who set out on foot when he could not afford the fare to Paris, had become a man of unstoppable determination.

Brancusi's ambition is discernible in more than the number of works he produced between the middle of

1904 and the beginning of 1908; it can be read in the stylistic shifts which mark this period, in the urge to move on and find new means. He arrived in Paris with the ability to make a faithful no-nonsense portrait, and was soon able to do so in a single sitting. He learned to touch the clay with Rodinian brio and even adopted the anatomical truncation introduced by the Master, at the same time struggling in vain at Beaux Arts to produce a full figure that would not look like a "cadaver"[3] to him. At a given moment the influence of Medardo Rosso and other nineteenth-century sculptors seems to refine his drawing, revealing a realm of delicacy and nuance more sympathetic to him than the robustness of Rodin. He undertakes unusual and poignant subjects—blindness, intense feeling, social protest—in an effort to break out of the confines of his technical skill, and with a success that is remarked even by Rodin. Finally, in *The Prayer* [2], he does a work that challenges the Master on

2. *The Prayer*, 1907.

3. A pointing machine.

his own ground. He proceeds to carve a number of heads in a vein of sensitive naturalism, but cannot fail to observe that he is still on Rodin's territory. It is now near the end of 1907, and there are worldly reasons for ambition: he is almost thirty-two, and up in Montmartre a young man has painted a canvas that is much discussed—the picture that will come to be known as *Les Demoiselles d'Avignon*.

But if there was a contest with Picasso, it could not even begin until he had got by Rodin. He was forced to conclude that it was not only impossible but pointless to challenge Rodin. "What could I have done better than Rodin," he asked, "and to what purpose?"[4] His immediate solution to the problem of Rodin was to give up his recent carving method and change to direct carving—*la taille directe*. This technique, unused by Rodin, would assure his liberation from the Master, and permit him to work in a new set of terms.

Ideally the direct carver uses only a hammer and chisels, and whatever other cutting tools he needs to fashion his stone or marble. He has no model of any kind; his hand is guided by the force of his conception, which in turn is influenced inevitably by the carving procedure and the material. Sculptors who consider themselves direct carvers sometimes work from a drawing, a rough study in clay, or from the memory of such a study. But whatever aids he may bring to his task, the direct carver does not use the "pointing machine [3]," a measuring device which makes it possible to reproduce faithfully—and even in another size—a work originally modelled in clay or a similar material.

Brancusi had studied decorative wood carving in Craiova, and may have essayed stone carving at some point in his many years of schooling, but he seems not to have made a sculpture in either wood or stone before going to Paris. In any case, sophisticated stone and marble sculpture in nineteenth-century Europe was carved almost exclusively from a model in plaster, and usually with the aid of calipers or the pointing machine. This

4

practice not only ensured exact reproduction of the sculptor's conceptions in much-prized marble, but freed him from the time-consuming task of carving and the repetitious labor of making copies in any number.

"Pointing" is a craft which can be pursued without the intervention of the artistic sense; in actual practice it is entrusted to a professional carver (in France, a *practicien*) or to an apprentice. Its ordinary use is merely mechanical, but it can also be employed creatively to correct, alter, and even enhance the original model.

Direct carving was, and still is, practiced by folk artists, by artisans executing decorations, and by primitive artists. The sculpture that results from this method of working is more conceptual, less naturalistic and nuanced, than that produced by modelling. The hardness of the materials and the relative difficulty in fashioning them influence the economy of the task and tend to impose a rigidity and frequent frontality on sculpture carved directly. Patience and skill can elicit from direct carving results as naturalistic, subtle, or intricate as those produced by modelling, but such work seems to the modern sensibility to be foreign to the medium.

If, in this century, direct carving has been espoused by sophisticated sculptors, it is from a conviction that when properly employed it produces, rather than reproduces, form. This form is considered to have a special character, to derive from the process, to be a direct and unmediated result, and for all these reasons is desirable. In the first decade of the century, directness gave promise of an art that would be fundamental, primitive, and honest; it became a prime value, providing an alternative to the technical and emotional subtlety of an over-cultivated tradition.

Direct carving calls for an artist endowed with a specific psychology. Clay, the material of the modeller, is amorphous, endless in its supply, conducive to accretion, and most important, able to be formed and transformed with great speed. It is responsive to the inspiration of the moment. Stone, on the other hand, always comes to the sculptor in a certain shape. This shape he often considers

to be a noble presence, and it is his pride to design in terms of it, not to add to it, not to weaken it, and to articulate it by removing as little material as possible. In any case, stone shape cannot be radically altered without great loss of material. Whereas modelling proceeds by any order of the acts of adding, removing, pushing, and twisting the clay, carving is a one-directional process in which mass is always diminishing and revision is haunted by the stone's attrition. Modelling is the ideal technique for temperamental, romantic, and improvisatory natures. Carving is deliberate, pondered, rigorous.

But whatever else it may be, direct carving is not a new technique, nor is it one which can be clearly defined. It is the technique practiced through most of the history of sculpture in stone, and the technique of most of the stone sculpture that exists. The term is never applied to carving in wood, for no apparent reason. In many cases the boundary between direct and indirect (or copied, or measured) carving is difficult to discern, nor in practice is the distinction always made.[5] It is often claimed that modelling is a means to an end—the bronze cast—whereas carving is an end in itself. However, we are brought up short by the paradox that most of Brancusi's direct carvings in stone and three in wood were cast in bronze or otherwise translated into metal, sometimes with little change in form. But while the carvings of Brancusi were as much a means to the ultimate bronze as any works modelled in clay, we must note that *The Kiss* was never, in any of its versions, reproduced in metal.

In short, the doctrine of direct carving was a mystique rather than a logical principle; its effects were polemical and heuristic. It was critical of the softness of clay and, by implication, of an art gone soft; it dispensed with the artisan; it rejected the inherited distinction between conception and execution; and it called on the constant alertness and sensitivity of the sculptor, who creates-in-carving. But mainly it was adopted in order to produce a new kind of form, and to authenticate the claim to a new vision.

As well as can be discerned, direct carving was one of

the "new ideas" at the beginning of the century. It was practiced by Jean Dampt, Aristide Maillol, Mateo Hernandez, and Joseph Bernard, of whom all except the last produced work on which the immediacy of the approach left no mark.

In the early years of its employment, direct carving had an importance for Brancusi which cannot be overstressed. Of six carvings he made in 1907, two are known to be copies of modelled originals, and were surely executed without the pointing machine, though possibly with the help of calipers. The other four carvings have a realism which suggests that they were done in the same manner,[6] although no modelled originals are known (they may have been carved from life, an approach Brancusi is known to have used in *Torso*, 1909);[7] a photograph of one of these is inscribed by Brancusi: *"première oeuvre en marbre."*[8] That all six were done from models of some kind—that is, were not *direct*—is indicated by the appearance at the end of 1907 of a head of a young woman which he labels *Première pierre directe* [4].[9] The work displays an altogether original sensibility; everything we know of Brancusi suggests that it is in some wise a portrait. But it is a sheerly stony expression that has no relation to clay and does not seem to imply the presence of a living model before the sculptor at the time of carving.

The designation *Première pierre directe* appeared under an illustration in *This Quarter* eighteen years after the work was created. The word *directe* is not used in the titles of the earlier marble carvings, and is strikingly indicative of the significance the head had for the sculptor. The title is the only one in *This Quarter* which points to a technique rather than to the thing represented, as do the titles of the thirty-three other illustrations of Brancusi's sculpture in the magazine.

This Quarter was an avant-garde journal whose first issue, published in Paris in 1925, devoted forty-six plates to Brancusi and his work, and printed two pages of statements and aphorisms, and a brief Aesopian fable by the sculptor. Among the notes on contributors in the back

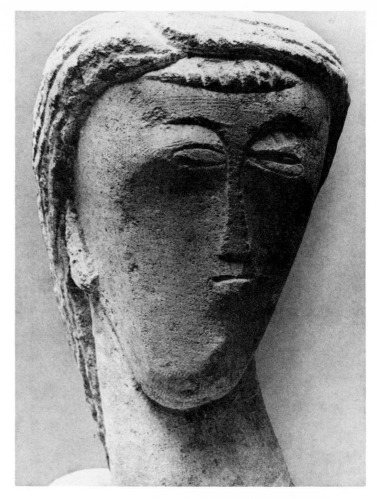

4. *Première pierre directe,* 1907.

pages of this issue, the remarks on Brancusi—a composite of direct quotation and editorial joinery—contain the following passage:

In 1907 he quit modelling and began *"la taille directe"* with *le Baiser et la sagesse.*

This reference to a change in Brancusi's working method is, again, the only technical note in the three hundred words devoted to the sculptor, and is a further sign of the

crucial importance to him of direct carving, even regarded after a span of almost two decades which were the most productive in his life. It overlooks the chronological primacy of *Première pierre directe* (which has disappeared from view), and points instead to the works that followed it, *The Kiss* and *La Sagesse*.[9a] For the stone head is, in spite of its attractions, a work with little reverberation beyond its remarkable style. The human head, a subject familiar to Brancusi, here seems to provide a convenient form in which to try the new approach. *The Kiss,* on the other hand, is the product of a number of more urgent forces.

From *Première pierre directe* onwards, every new design of Brancusi's was to originate in a carving,[10] but there is little in his work prior to this piece that presages the carver he was to become. In retrospect we may say that only his probity and sobriety prepared him for the carver's vocation.

A light flashed, it seems, or kept flashing for Brancusi as he carved *The Kiss:* he said it was his "road to Damascus."[11] And indeed the work marked for him a moment of revelation so luminous and manifold that it would permanently alter the course of his art.

In his first statement in *This Quarter* Brancusi says:

Direct carving is the true path toward sculpture, but also the worst one for those who don't know how to walk. And in the end, direct or indirect carving doesn't mean a thing—it's the finished work that counts!

The second sentence is the voice of reason; the first is an article of faith—the one he lived by for most of his life.[12] For surely, one of the revelations of *The Kiss* was the necessity of direct carving as a way of both working and thinking.

The Kiss [5] shows two lovers locked in a close embrace. We see only the upper part of their bodies; these are nude, but not insistently so. The man's chest is an undifferentiated mass; the woman's breast, encroaching on the form of the man, is gently profiled and has only a slight

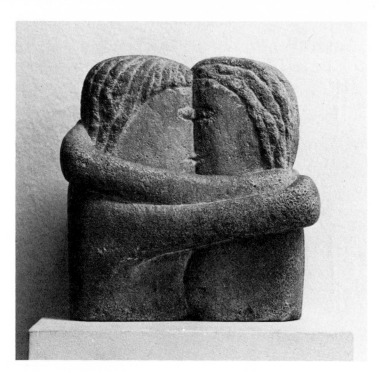

5. *The Kiss*, 1907–08.

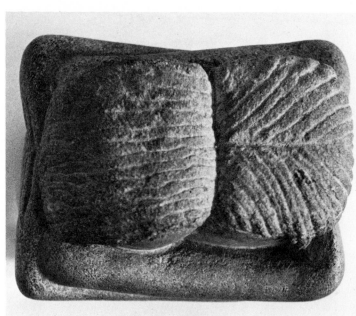

9. *The Kiss*, 1907–08, from above.

suggestion of fullness in the plane on which it lies. More arresting than the presence of bodies is the fact that the lovers are eye to eye, fixed in endless attention while their lips mingle.

Every element in the compact image is thematic, and our reading of the work proceeds in measured fashion as we note that the man's hair is straight, the woman's wavy; that his falls and hers goes back; his hair is parted, hers is not [9]; the woman's arms are above, the man's below; her in-curving fingers press his head to hers; his straighter, stiffer hands hold her body; the man's back is broader than the woman's; her hands, embracing the small mass of the man's head, overlap noticeably and point upward, whereas the man's hands go across the woman's back, just overlapping. These differences are formal variations in a symmetrical design, but they are also sexual distinctions. Form and meaning are here as tightly bound as the protagonists themselves. And these are bound not only by the visible horizontals of en-circling arms, but by the secret horizontals implicit in the eyes' glance, the lips' touch, the thrusting breast: this man and woman are joined from without and within. And underneath all is the continuity of the stony mass.

The sculptor's touch varies as it moves over his crea-tures [6]. Their hair is striated in a fresh style, while the hands and fingers are designed with great care. Taut sur-faces define the energetic regions of arm and back; a wa-vering skin of form contains the relaxed portions of face and body above and below the arms. In the sensitive areas of the lips and eyes, form is uncertain, dependent on the fall of light on each chipped facet and grain of stone: lips and eyes are spiritualized.

The Kiss is a product of the carver's, as against the modeller's, imagination. Conceived in the stone, its every surface has been won with the point, the chisel's edge, and the abrasive stone, and every surface is easily avail-able to these tools. The object is stable, its weight ac-knowledged, its density respected. Later Brancusi will carve with unflinching tautness, cut more deeply, pierce the material, stretch it to the breaking point, defy its

11

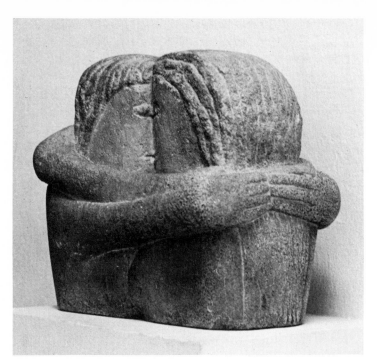

6. *The Kiss*, 1907–08.

weight, dazzle with the perfection of his design, but *The Kiss* is modest, solid, heavy, lithic. No *tour de force*, no exhibition of skill—it is a work of sheer art.

The intensity of the image is achieved in great part by a masterful elimination of anatomical features [7]. To the eternal question in this situation—"What happens to the noses?"—Brancusi responds by causing them to disappear. But similarly there are no ears. The position of the woman's arms removes the need to show chins and throats. Where the arms bend to become hands, Brancusi creates a perfect ambiguity: elbowrist. The general suppression of anatomical elements permits us to know just enough about this couple to know that they are a man and a woman. Because the faces are carved with a minimum of detail and in profile rather than frontally, we do not judge them psychologically. Brancusi's concision, which does not prejudice the impression of realism, often goes unnoticed, but its effect is immediate. Free of im-

pedimenta, the image speeds to the eye, invades the mind. What we see, and all that we see, is the kiss and mutual rapture of these lovers.

The carving of *The Kiss* entailed the abandonment of a gift Brancusi had spent ten years developing. Two years later he told Margit Pogany "that art was not copying nature."[13] With *The Kiss* art became for him a search for essence, the distillation of nature in sculptural terms—achieved in this first effort with incredible quiet boldness. That essence rather than resemblance could be the aim of sculpture was the second revelation of *The Kiss*. And there were others.

When we turn to the broad facade which has not yet been examined [8], we see what we expected to see; and if we see a little more and a little less, we are not surprised. The lovers are the same and they still embrace, but we note some small changes. The eyes here are rather circular than oval, and it is difficult to be certain whether

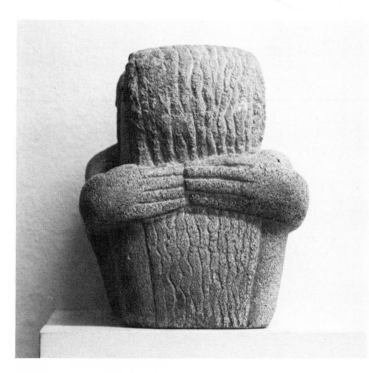

7. *The Kiss,* 1907–08.

13

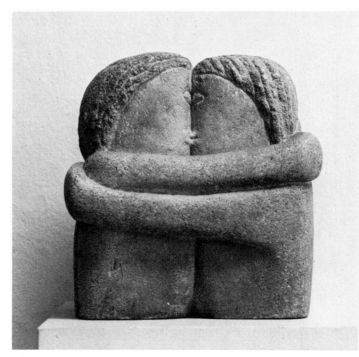

8. *The Kiss*, 1907–08.

they are open or closed. The arms lie parallel to each other, whereas on the opposite side the woman's arm rises at an angle to the man's. Below, there is no curving breast, this feature being suggested by the fact that the meeting of the bodies is further to the right than that of the heads. The contact of the heads and of the bodies is designated now by deep channels. The upper of these is bridged by the clearly fashioned lips. The depth of the channels seems to require the greater binding force inherent in the parallel arms, a force not required on the other side where the bodies seem almost to merge. This view of *The Kiss* is more dreamlike, less present than the other, more abstract and impersonal.

The problem of "the other side" is an especially sculptural one, and Brancusi will deal with it more boldly later. In *The Kiss* the other side must be like the side which is seen; but to be exactly like it would be banal. Brancusi has found a number of excellent reasons for the introduction of variations. These are not of the merely

14

formal kind often employed to jog bilateral symmetry; they raise the matter to a higher level. They are significant in their change of content; they play against each other in memory since they cannot be seen at the same time. They force us to consider the density, the impenetrability of the stony mass. They make us aware that the subject has, inescapably, more than one aspect. Yet they do not send us spinning around the sculpture in search of new views and unexpected effects. Our manner of regarding the work is rational rather than haphazard; seeing turns cerebral. We compare notations rather than accumulate impressions, and we deduce without effort what transpires on those facades we cannot see. The sexual distinctions noted earlier create, in their orderly opposition, a logic of construction which, in spite of the time that might be spent studying it, makes *The Kiss* intelligible immediately.

The problem of "the other side" is, in short, the problem of how, and with what speed, a sculpture of any bulk is grasped in the mind. This is accomplished in two ways. One is the accretion of information in a process requiring time, and movement around the sculpture which, in this case, is characterized by variety and surprise. The other is the immediate apprehension of the work from any reasonable vantage [10]. In the esthetic of immediacy, variety is nugatory, graphic incident is limited, and the expectations raised by that which is seen must be fulfilled by that which is not. With *The Kiss* Brancusi takes the latter course, deviating from it rarely in his long career.[14] The third lesson of *The Kiss* was that his sculpture would be grasped totally and at a glance.

The Kiss—whether Given, Returned, Refused, or Delayed—is a theme of ageless appeal in art. Only the theme of carnal love is more passional, only that of love for a child is more tender. The former is troubled, at least in the West, by great difficulties at the level of tact; the latter easily succumbs to sentimentality. Avoiding these extremes as it does, the Kiss has proved an engaging vehicle for the representation of intimacy since antiquity

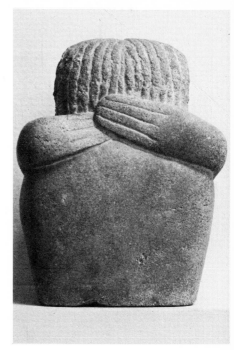

10. *The Kiss,* 1907–08.

15

and almost universally. A prehistoric carving from the Wilderness of Judah[15] shows an embracing couple; luminous Kisses are a respite from the amorous acrobatics of Konarak.

Whether the Kiss in its many representations stirs memory or fantasy in the viewer, for the artist its appeal lies in the confrontation of two faces and the meeting of two bodies. But the doubling of these images presents a challenge, since the Kiss has a set of graphic problems specific to it. First, it brings two noses into a proximity which, as we shall see, is peculiarly vexing; we have already encountered this situation and its solution in Brancusi. Then, it raises the matter of the lovers' arms, an issue easily disposed of by the painter or draftsman, who need not show more than two, but which taxes the invention of the sculptor, who is constrained to account for all four. Finally, the sum of limbs is increased to eight whenever the legs are to be represented.

On a stone relief [11] found at Osuna, Spain, a woman and a man are seen in profile facing each other. In the symmetrical design their heads are thrown back just enough to permit their lips—but not their noses—to meet as they kiss. We must suspect that it was to prevent the noses from crossing, and thus avoid the difficulty of representing this situation in relief, that the artist threw back the heads of his couple, forcing them to kiss in a strained position.

A relief in marble, Greek,[16] of the first century B.C., shows a nude young couple kissing energetically, or involved in a struggle over a kiss. The artist has taken advantage of the flatness of relief to show only two arms and three legs. The man's nose encroaches on the woman's face, a metaphor for sexual aggressiveness.

A twelfth-century Romanesque capital on a low column in the choir of the Basel Groszmünster [12] shows an embrace in a horizontal position: the lovers' faces are opposite each other; their eyes are open; the woman's short outstretched arm—very like those in Brancusi's *Kiss*—

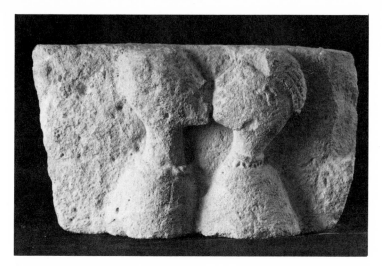

11. Relief from Osuna, Spain.

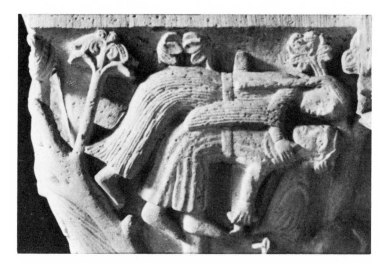

12. Capital, Basel Groszmünster.

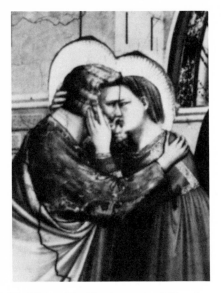

13. Giotto, *The Meeting at the Golden Gate*.

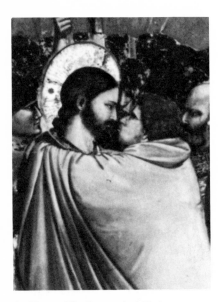

14. Giotto, *The Betrayal of Christ*.

holds the man. But his open eyes do not see; his arm falls back: he is Pyramus and she, Thisbe. It is altogether possible that Brancusi saw this carving when he passed through Basel early in 1904 on his way to Paris.

Two panels in the Arena Chapel frescoes at Padua include arresting examples of the Kiss by Giotto. In *The Meeting at the Golden Gate* the embrace of Joachim and Anna [13] has several features which relate to Brancusi's sculpture: the hair framing the faces, Anna's hand behind Joachim's head, the opposed and open eyes. But surely there is a problem in the region where the faces meet. The lips just touch, Joachim's nose passes over Anna's, yet the plane of symmetry of Anna's head is not tipped. Anna's face, except at the lips, appears to penetrate Joachim's profile, an illusion which Giotto obscures by having Joachim's beard cover the end of Anna's chin. In *The Betrayal of Christ* we witness the moment before a Kiss [14]. Prominent in this drama are the opposed noses of Christ and Judas; but between their brows are the thrusting noses of two soldiers. Probably nowhere else in all of art are four noses shown in so small an area as in this painful scene. And Giotto compounds their troubling effect by designing Judas' brow like another nose. As in the Greek relief, the prominent nose portends antagonism.

An Ashanti goldweight[17] [15] represents a couple face to face; their arms encircle each other, the woman's legs straddling those of the man. Since they kiss with pouting lips, there is no contact of the noses which, in any case, are not prominent. Bolivian natives in our own day carve a love charm[18] [16] of an embracing couple which leaves spaces between the heads and bodies. Eyes are defined, but not noses; as in the African piece, the woman's legs go around those of the man. These primitive works are surprisingly similar to Brancusi's *Kiss* in both spirit and design.

Rodin's *The Kiss*, 1888 [17], marks a high point in the modern treatment of the theme, inspiring a generation of followers and setting a standard that would not be equalled. His lovers kiss frankly while comfortably seated

18

on a rock; later versions of the theme declared their originality by posing the lovers in uncomfortable attitudes and theatrical situations, though rarely seated on a rock. Most favored was the standing Kiss like that by Jules Dalou [18], who replaced the usual man by a horned and cloven-hoofed satyr. The hair of the satyr's head is boyishly short, but he wears a bushy mustache which covers the woman's mouth. In 1906 M. L. Béguine exhibited *The Embrace* [19], an incipient Kiss in which the woman is supine on the lap of a crouching man. If her right foot were not snugly tucked in the bend of her left knee the fleshy couple could be thought to be wrestling.

Since Brancusi had been influenced by Rodin, had worked for him briefly, and had turned away from him,

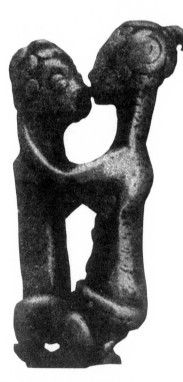

15. Ashanti goldweight.

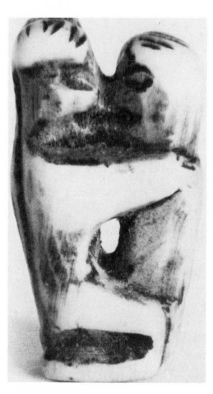

16. Bolivian love charm.

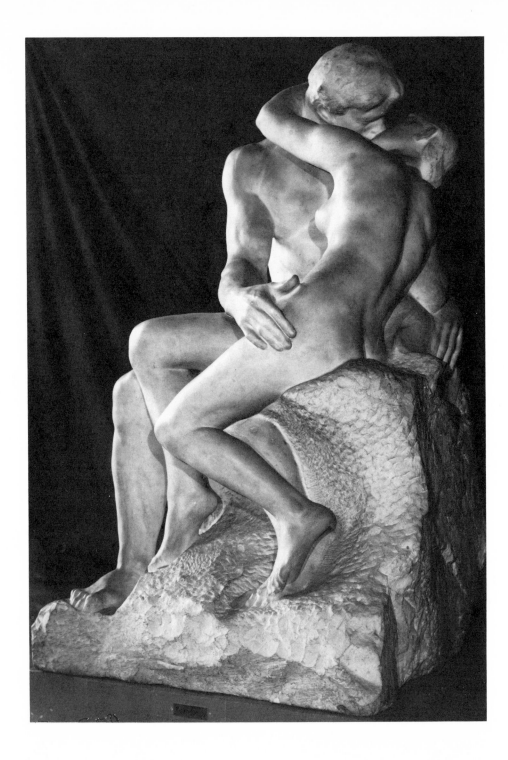

17. A. Rodin, *The Kiss*, 1888.

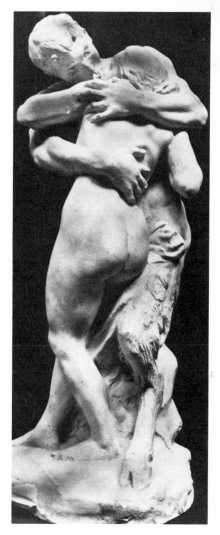

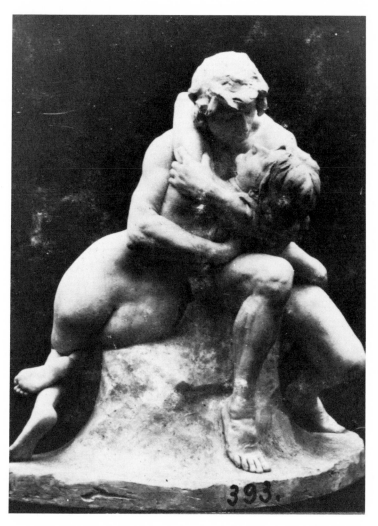

18. J. Dalou, *The Kiss*.

19. M. L. Béguine, *The Embrace*.

it can be supposed that the famous marble version of Rodin's *Kiss* was much on his mind as he carved his own. He was among the first of the new century's sculptors who would not follow the Master of Meudon, and his *Kiss* has all the appearance of a declaration of independence, designed to oppose Rodin's at every point. The two works, in any case, constitute a paradigm of artistic polarity.

Brancusi's *Kiss*—small, squat, in unexceptional limestone—challenges the large, tapering, gleaming marble. It is carved by the sculptor himself, in a composition that is clear, rational and foursquare; the Rodin is intricate, "inspired," and transferred by technicians from the original modelled version. Rodin's protagonists are an immediately identifiable man and woman of great beauty; their splendid anatomies imply movement and existence in time. Brancusi's personages are designs in which difference in gender is indicated by gentle variations; one could not pronounce on the beauty of these creatures; their kiss, enacted in an eternal present without prelude or sequel, is precisely as still as the stone in which it is carved. The man's head, in the Rodin, overhangs his partner's; the absolute difference between the sexes is symbolized by the fact that the planes of symmetry of the heads meet at right angles. In the Brancusi neither lover dominates in any way; they embrace as equals. With easy mastery Rodin deploys the difficult four arms and four legs without creating a tangle of limbs; Brancusi eliminates the legs and lower torsos. Given the realism of his portrayal, Rodin tactfully arranges for space between the torsos and a varied use of arms. Brancusi's schematism permits unbroken contact between his lovers. We may imagine this contact to take place along a lengthy vertical groove—which might well suggest division; but the round, horizontal pairs of arms defeat this caesura both graphically and conceptually. Surely aware of the troubles that attend the closeness of two noses, Rodin avoids the problem and, besides, obscures the region where the faces meet. Indeed in Rodin's *Kiss* the meeting

of lips is a small feature of a large, complex situation; in the Brancusi it is revealed and central.

A crucial difference between the two artists is manifested in their attitude toward the sculptured object. Rodin's lovers are continuous with the rock on which they sit and with the ground below, rock and ground serving as a base. This base supports the otherwise unstable arrangement of the lovers and holds its parts together. Brancusi's *Kiss* terminates where his lovers terminate, and since they are congruent with the stable, solid object he has carved, they are as stable and strong as it. Henceforth, every work of Brancusi's will be (or become) a self-contained *object*. The limits of this object will be those of the creature he portrays; it will be capable of maintaining itself without support in a position intended by the sculptor; it will not be integral with any kind of "ground," or with a base or other stabilizing device. If it will be attached to a base, it will be so for safety's sake— in the case of a precarious equilibrium—or to maintain it at a desired height. Whereas Rodin, Matisse, Duchamp-Villon, Archipenko, and other sculptors in the early part of this century *sometimes* made sculpture which was not integral with a base, from *The Kiss* onward Brancusi *always* made such sculpture. This absolute distinction is the sign of a radical shift in sensibility. Brancusi's immediate sculptor's task is to make discrete objects. His subjects become these objects, but they are always objects in the first place.

Closely related to these considerations of the sculpture as object is Rodin's and Brancusi's understanding of the space in which their creatures exist. In showing more than his lovers, Rodin creates the illusion of a situation, a fictive space which is consonant with the illusion of reality in his protagonists. In contrast, Brancusi shows only the lovers; these much stylized figures make a design which very properly exists in real space—our space. That the subject could become an object and this object exist in actual space were for Brancusi further revelations while making *The Kiss*.

Although every feature in the Brancusi up to this point is opposed to its counterpart in the Rodin, there is one other which is indebted to Rodin. The modern truncated figure or anatomical fragment is Rodin's invention, and gives Brancusi permission to end his figures at mid-torso. Yet the viewer of *The Kiss* experiences no sense of loss, of an instrument having cut across a body, even the sculptural body. In a work where every feature becomes a design, the truncation of the body is absorbed as design, without the violence or pathos which results from both Rodin's and Brancusi's own earlier use of this device. It gives Brancusi the clue to future, more daring truncations which will be a way of designing *a priori*, rather than being actions visited on parts of a more complete anatomy.

In the last years of the nineteenth century and the first years of the twentieth, the Kiss increasingly engaged the efforts of artists other than sculptors. At the height of Art Nouveau a famous print by Peter Behrens showed a tender, eyes-closed kiss framed by the lovers' intertwined hair [20]. The lips meet, the man's nose lies across the woman's; this is a period when it was apparently impossible to depict a kiss with the woman's nose in the foreground. But the artist's insistence on delineating the woman's nostril has inadvertently created a curving mustache shared by both faces. In the Kiss the nose is the final test.

Edvard Munch did a number of works on the theme, including a grisly *Girl and Death* on both canvas and paper. His well-known etching of a nude couple, 1895 [21], and a later woodcut of clothed figures in the same pose, portray lovers joined in a passionate kiss; their forms merge, especially in the region of the heads where no facial details are visible. In 1900 Steinlen drew lovers kissing in the street, and Picasso made a pastel and an oil painting on the same theme [22], the latter exhibited in Paris late in 1904 when Brancusi might have seen it. Picasso's versions retain the facial features, with the embrace accomplished by horizontal arms. The arms again go straight across the two bodies—as they do in Bran-

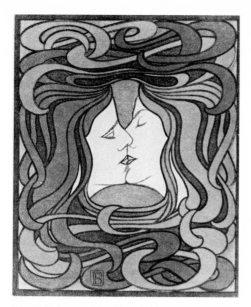

20. P. Behrens, *The Kiss*, 1898.

22. P. Picasso, *Lovers in the Street*, 1904.

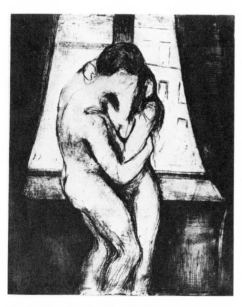

21. E. Munch, *The Kiss*, 1895.

25

cusi's *Kiss*—in a Picasso drawing of 1900 [23] where the facial features are obliterated. In the Munch etching the man's arm is bent, creating a chevron which is one of the afflictions of the Kiss. When Picasso does a realistic study for *La Vie*—*The Embrace* of 1903—the arm bends at the elbow, but the gesture here is protective rather than passionate.

It is possible to point to a number of sculptured Kisses which Brancusi would surely have seen in Paris before carving his own. An unidentified Kiss, in plaster, between a mother and child [24] includes the horizontal arm, bared breast, and the half-torsos evident in Brancusi's version. This much deteriorated work dates from the beginning of the century; it has been exposed to the weather for decades on a walk alongside the central building of La Ruche, the crowded artists' village in the 15th Arrondissement which in all likelihood Brancusi frequented in the years following his arrival in Paris.

At the Société Nationale of 1905, Félix Voulot, two of whose works are in the Louvre, exhibited *Le Pardon*, in plaster [25], and *Le Baiser*, listed in the catalogue as *deux*

23. P. Picasso, *The Embrace*, 1901.

24. Unknown sculptor, *The Kiss*.

26

têtes en marbre, possibly a copy of the heads of *Le Pardon.* The latter work demonstrates the difficulties—surely not satisfactorily resolved—which attend the arrangement of the lovers' arms. *Tendresse* [26], a group in marble by R. C. Peyre, exhibited at the Salon des Artistes Français of 1906, though not a Kiss, is a further example of the problems that trouble the representation in sculpture of the embrace of two nude figures. Béguine's *The Embrace* [19] was shown in the same Salon.

At the Salon of 1899, Emile Derré (b. 1867) exhibited a *Chapiteau des Baisers* in plaster [27] which was acquired by the state. Four Kisses—of Love, Maternity, Consolation and Death—were figured on the corners emerging from a matrix of fruit and flowers. The Kiss of Love resembles Brancusi's in showing only the upper part of the body and featuring the woman's breast. The young man wears a full mustache, the couple are about to kiss—their

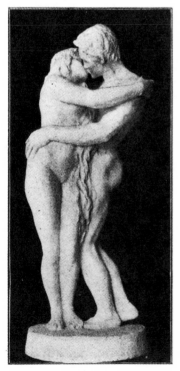

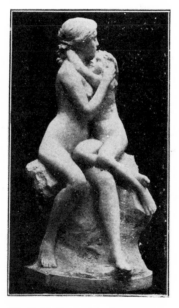

26. R. C. Peyre, *Tendresse.*

25. F. Voulot, *The Kiss.*

27

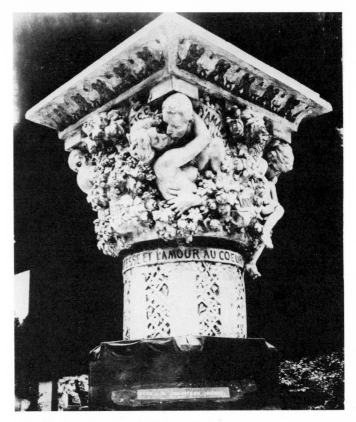

27. E. Derré, *Chapiteau des Baisers*, 1899.

noses seem to be in the way. Derré exhibited the capital
again in 1904, this time with the Kisses on the sides of
the capital, and he was commissioned by the state to ex-
ecute a column in permanent form. In 1905 he carved *La
Grotte d'amour*, a deep relief in marble [28], which was
shown at the Salon d'Automne of 1906 (where Brancusi
also exhibited). The nude lovers are ready to kiss, an act
that calls forth a great muscular effort on the part of the
male. But his horizontal arm is suggestive of the arms in
Brancusi's *Kiss*, and the whole work would seem to be
the source of Maillol's high relief, *Desire*, 1906–08.[19a] At the
Artistes Français of 1906 Derré showed his reworked *Cha-
piteau des Baisers* in stone; later that year the column,
with four heads of beagles guarding its base, was erected

28

in the Luxembourg Gardens, where Brancusi certainly saw it, and where it may still be seen today.

Derré's sculpture was accessible, it dealt with a theme that interested Brancusi, and did so in a manner that shows similarities to the latter's handling. But there is yet another reason to believe that it aroused Brancusi's attention: Derré's column was noticed in the press in a special fashion. The *Gazette des Beaux-Arts* favored it with a reproduction in a review of the Salon which described it as an *"oeuvre . . . rêvée pour une Maison du Peuple et où d'ailleurs la figure aimée de l'évangélique anarchiste* [Louise Michel] *joue avec celle de Blanqui un rôle essen-*

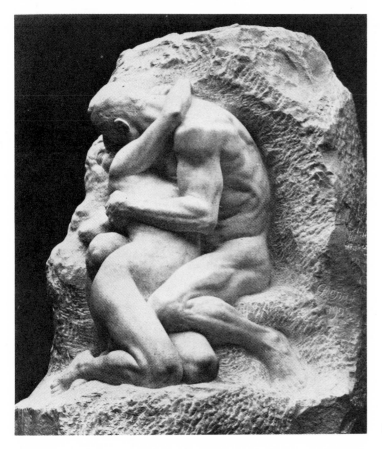

28. E. Derré, *La Grotte d'Amour*, 1905.

29

tiel . . ." [19] In the article on French sculpture in the 11th edition of *Encyclopaedia Britannica,* December 1910, Léonce Bénédite, director of the Musée du Luxembourg, referred to "E. Derré, an inventive decorator, with social tendencies and grateful emotional feeling [sic]." The column itself is inscribed with the words, *"Pour la Maison du Peuple . . ."* Derré's political sympathies would have made him attractive to Brancusi who, in this period, himself had strong socialist leanings. [20] A decade later he would undertake a work whose final form, *Column of the Kiss,* 1930, would be greatly indebted to Derré's column.

In the fall of 1907 Daniel Kahnweiler exhibited *Crouching Figure* [29], a stone carving by André Derain, in his new gallery in Rue Vignon [21] where there is every likelihood that Brancusi saw it. If *The Kiss* by Rodin is the great negative influence on Brancusi's *Kiss,* Derain's work must be considered the latest and most important of several direct influences.

Crouching Figure shows a personage whose arms embrace doubled-up legs and terminate in large hands and interlaced fingers. The points of resemblance between it and *The Kiss* are numerous and striking. Both are in limestone and are carved directly. The former measures 13x11x11"; the latter, 11x10x8½". Both are compact orthogonal masses. Both show encircling arms, emphasis on the hands, nudity in the figures, and general symmetry of design.

Crouching Figure has serious shortcomings: it does not reveal itself readily, it fails to establish an inner logic or reason for the protagonist's posture, and is poetically unevocative. But Brancusi would have been struck by its boldness and would have recognized it at once as a stylistic and technical innovation. The work declares itself to have been conceived in the stone and carved directly, apparently without a preliminary drawing, [22] and its raw style seems to be the result of this process. Derain preserved the essential character—the stoniness—of the material (or invented a new stoniness) and articulated a

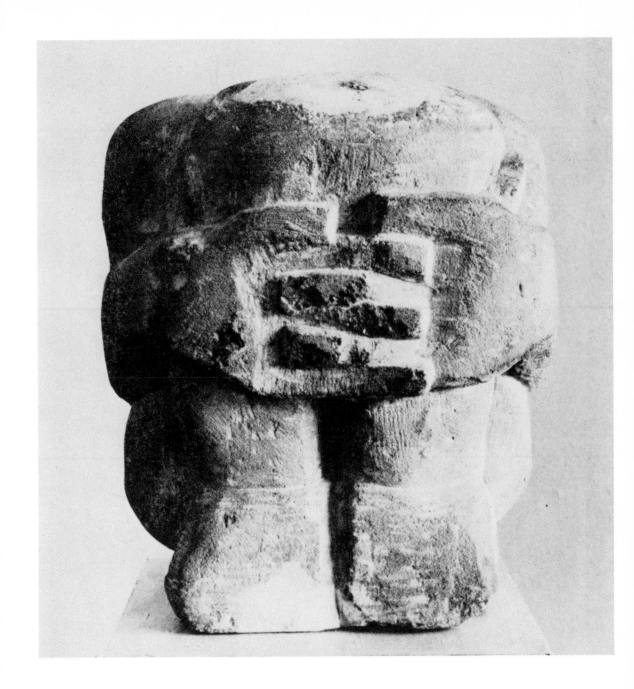

29. A. Derain, *Crouching Figure*, 1907.

difficult mass without making deep incursions into it. His compression of a figure within the scope of a block is a *tour de force*, which at the same time appears to be dictated by the resistant material. Unencumbered as he was by the culture of European sculpture, Derain was able to recognize the consequences of Gauguin's sculpture and develop them in a single bold move. *Crouching Figure* is the first direct carving in the modern tradition, and its impact on Brancusi would have been all the greater because his own recent efforts had been pointed, however tentatively, in the same direction.

Derain's very few carvings—two or three—of this moment have been regarded as the remarkable but uncharacteristic efforts of a painter. There are two respects, however, in which they are not singular: they are related to Derain's own paintings and to Matisse's sculpture. For the fact is that the two greatest exemplars of Fauvism also made noteworthy sculpture. Matisse's bronzes of the period 1903–07, originally modelled in clay, have the same facture, the same freshness and immediacy of touch, as his paintings. Their drawing and surface record the artist's gesture, itself an emotional response to observed form rather than an attempt to reproduce that form. The coruscation of the bronze is the counterpart of broken color on the canvas, just as the strongly accented postures in the one echo the bold patterning of the other. Both show the same elision of form, the same occasionally total reliance on the heat of inspiration at the moment of execution—however often that moment may have been repeated. Derain, for his part, achieves in stone the equivalent of the Fauve painter's immediacy of touch, bold design, and limited palette by carving directly in strong shapes devoid of nuance. The early bronzes of Matisse and the carvings of Derain should be recognized as *Fauve sculpture,*[23] an integral part of the first artistic movement of the century.

Brancusi's relation to this movement is more complex than the fact of similarities between *The Kiss* and *Crouching Figure*. From the moment that Brancusi is touched, as

I think, by the Derain sculpture, he enters the orbit of Fauvism.

At the Salon d'Automne of October 1907, in which Brancusi participated, Matisse exhibited *Music (Study)* [30], painted that same year. In the upper right of the small canvas two girls embrace as they dance, the upper part of their bodies making a design similar to that of Brancusi's *Kiss*, [24] although they do not kiss.

But two sculptures that Brancusi carved right after *The Kiss—La Sagesse*, 1908 [31], and the so-called *Double Caryatid*, ca. 1909 [32]—are no less similar to the other figures in the painting: the seated woman and the standing violinist. The three carvings by Brancusi belong to the same universe of form and sentiment as a whole sequence of paintings by Matisse: *Music (Study)*, 1907; *The Game of Bowls*, 1908 [33]; *Nymph and Satyr*, 1909; and *Music*, 1909 [34]. Seen in the context of this group of works and of related paintings by Derain, Brancusi's sculpture of 1908–09 has an unmistakable affinity with late Fauvism.

One of the fantasies of *fin de siècle* Europe was that of escape from civilization, of a journey to the Enchanted Isles, a return to the bosom of an unspoiled nature. The fantasy was lived out in brutal fashion by Rimbaud, who left art for Africa and a life of gun-running; death came by gangrene and syphilis in 1891. In the same year Gauguin left France for Tahiti. He was also to suffer, though less terribly than Rimbaud, in following the dream of escape, but unlike the poet he escaped *as an artist* and left a record of his sojourn in Eden.

As the news of Gauguin's death reached Paris in 1903, a small memorial exhibition of his paintings was hastily mounted which did only limited justice to the artist. But at the Salon d'Automne of 1906, which ran from October 6 to November 15, Parisians were able to see the great Retrospective organized by his friend, the critic Charles Morice: paintings, drawings, prints, sculpture, and ceramics in even greater number than the 227 items listed in the catalogue. In the full display of a rich and erratic

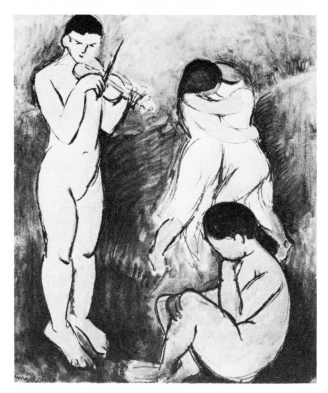

30. H. Matisse, *Music* (*Study*), 1907.

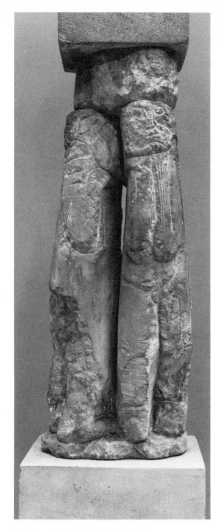

32. *Double Caryatid,* c. 1909.

34

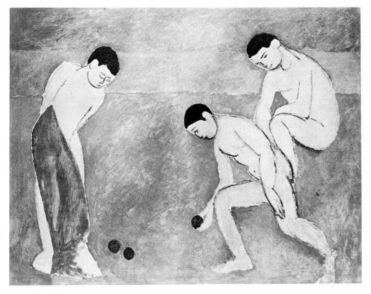

33. H. Matisse, *Game of Bowls*, 1908.

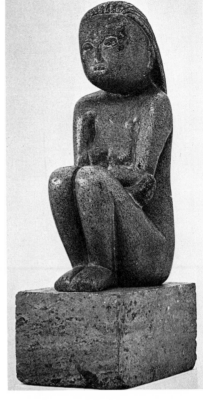

31. *La Sagesse*, 1908.

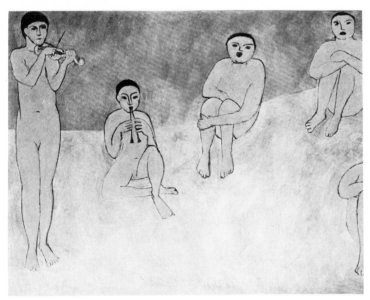

34. H. Matisse, *Music*, 1909.

career, the artist and his myth were finally joined, but it was the legendary rebel, the Gauguin of the South Seas, who touched the imagination of artist and layman alike. Here in exotic landscapes were brown-skinned Polynesians wrapped in bright sarongs or clothed in their unself-conscious nudity, calmly standing or seated on the friendly earth, flowers in their hair, looking out at the viewer with a glance free of guile. While the paintings and drawings reflected the vestigial primitivism of the Marquesas as seen by a sophisticated modern artist working in the French tradition, the carvings in wood and stone were frankly primitivizing. The prints seemed to reinvent the medium.

The effects of the Gauguin Retrospective were felt at once in many areas of the fine and decorative arts, and nowhere more strongly than among the *fauves*. The interest in primitive sculpture, which had recently gripped Derain and Vlaminck and then Picasso and Matisse, was confirmed by the exhibition. Derain's *Crouching Figure* appeared a few months later. [24a] And the painting of Derain and Matisse changed its character in the three years that followed. The energetic composition and volatile color of the previous period were restrained. A simplicity of drawing and a primal calm and dignity invaded the canvases of the two artists as they painted a vague Ile de France become Eden. A few months after the Retrospective, Picasso made a number of primitivistic carvings and embarked on a large painting of many nude figures, known at one point as *The Philosophical Brothel*, which would be an urban echo of Gauguin's "philosophical" frieze, *Where Do We Come From? What Are We? Where Are We Going?*

In a photograph taken in Brancusi's studio toward the end of 1907 [35] we can see five carvings—three of them in marble, two in stone—done that year, and all executed without recourse to the pointing machine. They are the evidence of an effort to carve directly, probably under the influence of the carvings in the Gauguin Retrospective which they follow immediately. But they also show Brancusi in the grip of the naturalism in which he was

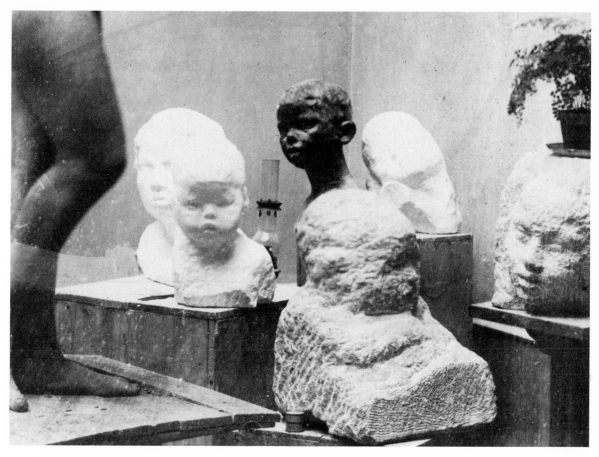

35. Brancusi's studio, Rue du Montparnasse, 1907.

schooled, in spite of the fact that two of them were
worked solely with the point, the crudest of carving
tools. In these pieces Brancusi appears to have been
touched only by the directness of Gauguin's technique.
But from the moment, as it seems, late in 1907 when he
saw Derain's *Crouching Figure* at Kahnweiler's, the lesson
of Gauguin—that the new technique produced a new
form—was forced upon him as effectively as upon Derain
and Matisse, and would influence his imagery for some
time to come. Indeed, the design of *The Kiss* may be di-
rectly indebted to Gauguin's relief, *Hina and Te Fatou*
[36], which, with a print of the same subject, was in the
Retrospective.

37

Brancusi's conversion—late in 1907, a year after the Retrospective—to a realm of feeling in tune with the elemental world of Gauguin was inspired by the example of a small group of daring painters who had struck out in new directions while he was studiously attempting to stretch the confines of an established tradition.

Brancusi's sudden change of course may well have been abetted by another factor, an encounter with Charles Morice, whom he would have met, probably in 1907, in the apartment of Otilia Cosmutza. This Rumanian-Hungarian journalist lived from 1905 to about 1910 at 22 Place Dauphine where she attracted a group of

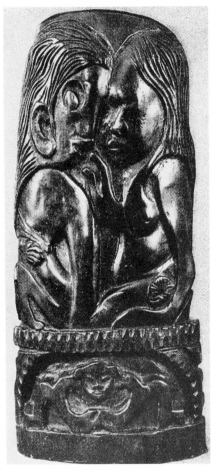

36. P. Gauguin, *Hina and Te Fatou.*

well-known writers and artists to what soon became a salon. Its members included, among others, Rodin, Anatole France, Morice, Pierre Loti, Colette, the Hungarian poet Endre Ady, the Rumanian painter Theodor Pallady, who lived at No. 12, and Brancusi, who had a top-floor studio at No. 16 from mid-1905 to early 1907. To their gatherings came the young woman who would be the model for Brancusi's *Sleeping Muse.* Mrs. Cosmutza was an admirer of Brancusi's sculpture and praised it highly in two letters from Paris published in 1908 in the Rumanian magazine *Luceafărul.* Early in the following year Morice mentioned Brancusi favorably in the same journal.[25]

Charles Morice (1860–1919), critic and poet, was the passionate advocate of a series of artists and causes, and a prominent figure in the intellectual life of the Left Bank for several decades. Camille Mauclair describes him at the height of his first fame: ". . . bearing on his long emaciated body the head of a romantic pianist—which later resembled that of Don Quixote—he was solemn, intense, mysteriously burdened by profound thoughts, and passed as nothing less than the Ruskin of imminent art."[26] His *La Littérature de tout à l'heure,* published in 1889, was a statement of the Symbolist position, a long, intricate, and impressive work which raised high hopes for his future, expectations which were never quite fulfilled in spite of his great activity and a succession of studies of Verlaine (1888), Carrière (1906), and Gauguin (1919). In the first years of the century he wrote a number of articles on Gauguin, whom he had known in 1890, and collaborated in the publication of Gauguin's *Noa Noa,* contributing, besides editorial labors, a few poems of his own composition. In 1907 he inaugurated and presided over a series of dinners held on the fourteenth of the month, which were attended by the leading artists and writers of the day, among them Carrière, Apollinaire, and Matisse. In April 1908 Rodin engaged him as his secretary; Morice eventually edited Rodin's *Cathedrals of France.*

Once a leading theoretician of Symbolism, he enjoyed a new prestige in 1907 as a result of his work on the

Gauguin Retrospective. We may imagine him as the eloquent champion of Gauguin in the Cosmutza circle. At a critical moment in Brancusi's development he may have intensified in Brancusi the effects of the Retrospective. It even seems possible, because of his special relation to the oeuvre, that he made certain works by Gauguin available to the sculptor.

Some striking parallels in the thought of Morice and Brancusi may further attest to the influence of the critic on the artist. In a prefatory note to *La Littérature de tout à l'heure*, Morice states that the "real orientation" of the book is "set" by its fifth chapter, entitled "Commentaries on a future book." This note closes with the words: "Theories are only as good as the work." A later aphorism of Brancusi took the form: "Theories are samples without value. Only action counts." The epigraph and opening paragraphs of Morice's important fifth chapter are worth quoting:

> ". . . In abstraction, dream and symbol."
> M. Taine.

> While waiting for Science to end conclusively in Mysticism, the intuitions of Dream arrive there before Science, and there celebrate that still future and already definitive alliance of the Religious and the Scientific Sense, in an esthetic festival in which burns the very human desire for a reunion of all human powers by a return to original simplicity.

> This return to simplicity is the whole of Art. Genius consists—like Love and like Death—in releasing from the accidental, the customary, the preconceived, the conventional and the contingent in all its forms, the element of eternity and unity which, contrary to appearances, gleams in the depth of all human essence.

> Singleness, unity, is the divine and affirmative number . . .

This text, with its vision of simplicity and unity, its emphasis on the eternal and essential, freed from contingency, could serve as a program for *The Kiss* and the oeuvre that would follow, and it is tempting to think that Brancusi was affected by it.[27]

Apart from the currency of the Kiss in contemporary art, the factors that seem most directly to have contrib-

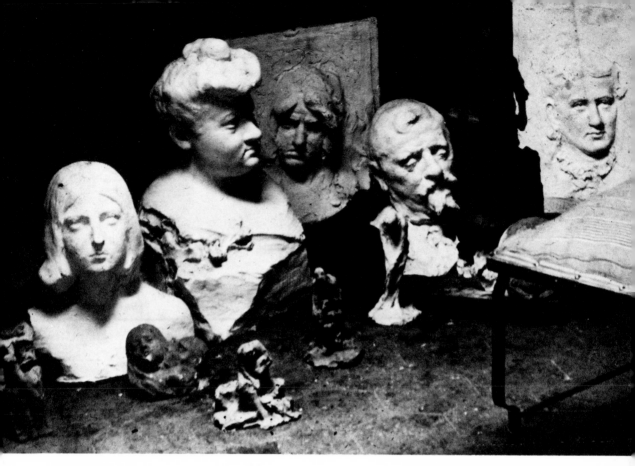

37. Brancusi's studio, Place de la Bourse, 1905.

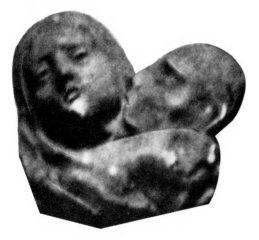

38. Detail of the studio.

uted to the creation of Brancusi's *The Kiss* are three: the exhibition of Derain's *Crouching Figure* at Kahnweiler's; the display of Matisse's paintings, notably *Music (Study)*, at the Salon d'Automne; and meetings between Charles Morice and Brancusi. These three factors would all have impinged on Brancusi in the fall of 1907. Behind all of them stands the Gauguin Retrospective of 1906, one of the most important events in the history of twentieth-century art. But there is yet another, older, all but submerged episode which, from a distance, set the enterprise of *The Kiss* in motion.

A remarkable photograph of a corner of the *sixième* that Brancusi occupied at 10 Place de la Bourse in 1905 [37] shows an early state of *Pride* (Muzeul de artă, Craiova) and eleven other sculptures dispersed on the floor beyond the end of a metal frame bed. Without the study for *Pride* and Brancusi's writing on the back of the photograph, it is not likely that the other works would ever be attributed to him. These include three portraits, one of which is barely distinguishable, two reliefs, and six small pieces, several of which are the size of bibelots. Although at first glance the twelve objects appear to be scattered over the floor, on examination their placement exhibits a high degree of order, and it is then reasonable to assume that the work situated directly in front of the study for *Pride* is not there by chance.

In this small work [38]—it was hardly more than four inches high—a young woman averts her head in distaste to avoid the kiss of a rather beastly man. The young woman, with her long hair parted in the middle, bears an unmistakable resemblance to the young woman in the adjacent study; the man has his hair cut in a fringe, just as Brancusi wore it in his early days in Paris. We are led to suppose an episode of a repulsed kiss involving Brancusi and the model for *Pride*, of whom nothing is known except that she posed at the Ecole des Beaux-Arts.[28] Brancusi kept the small group, which we may call *The Rebuff*, for at least two years: in a photograph taken in his studio on Place Dauphine toward the end of 1906 it is just visi-

ble on a small table between Otilia Cosmutza and Mrs. Ştefan Popescu, a Rumanian friend;[29] the little group had become a conversation piece, but for the sculptor it was a memento, perhaps an exorcism, of a painful episode. It appears for the last time alongside the completed plaster of *The Prayer,* in a photograph taken in the latter half of 1907.[30]

If it is justifiable to see *The Rebuff* of 1905 as the record of a kiss refused—in the real or dream life of Brancusi—it is worth considering whether *The Kiss* of 1907–08 celebrates a similar but consummated kiss. In the absence of documents pointing to such an event, the sculpture must be consulted.

A close examination of *The Kiss* [1] on the facade that shows the female on the right reveals a set of details that may easily be overlooked. The front of the man's head dips lower than that of the woman, making him appear shorter than her. His hair, cut in a fringe, falls over his brow, while the woman's hairline is noticeably higher, making her face—which is narrower than the man's—appear much longer. The man's eye bulges, creating a shadow which causes it to appear dark, while the shallowness of the woman's eye shows it to be pale. Finally, the woman's lower lip has a fullness not visible on the man. These slight deviations from bilateral symmetry on the sculpture are not accidental—the difference in height recurs in other versions of *The Kiss;* nor are they formal or conventional—convention would have dictated greater height in the male. They suggest a biographical origin.

And indeed the facial characteristics of the man and his shortness of stature were those of Brancusi himself. The sculptor wore a beard which does not figure in *The Kiss;* the inclusion of this motif would have given rise to a strong asymmetry and an undesirable—because self-advertising—explicitness. The facial features of the woman appear in no less than six carved heads by Brancusi.[32] They are also to be found in a work fashioned in clay, *The Prayer,* 1907. The model for this piece would have been taller than Brancusi; the head has been rendered in an untypically summary style.

A curious fact underlines the very personal character of *The Kiss:* although Brancusi numbered many of the younger artists and writers among his friends, there is no record of anyone having seen the work in his studio, nor was it shown publicly in Paris. Its apparent concealment is the more surprising since, by all signs, Brancusi was aware of its importance and would have relished the attention that public display would have aroused. One cannot help speculating that he was reticent to exhibit in Paris his most unusual piece to date because its personal tenor might cause embarrassment to the well-known young woman who had inspired it. It would seem to be for the same reason that he permitted *La Sagesse*—made right after *The Kiss* and second only to it in importance— to go to Bucharest without having been seen in Paris. And it is likely that the head of *The Prayer* was modelled in its rough fashion in order to obscure the identity of the girl who had posed for it in the nude.

Propelled by a private episode to the creation of *The Kiss,* forced by considerations of tact to withhold from Parisian attention his most original work, Brancusi nevertheless realized that henceforth his sculpture could absorb the events of his life. Thirty years later, doubtless tired of the lofty critical attitudes which his sculpture had long attracted, he complained to a friend in Bucharest that "aesthetes have an aversion to biography."

In the absence of a personal impulsion *The Kiss* would have been a subject uncongenial to Brancusi since it requires two figures. Up to this time his only compositions of more than one figure—as well as one can distinguish in old photographs—were three or four very small studies; in the future his only such compositions would be the rough *Double Caryatid* [32] and *Penguins,* unless the columnar *Adam and Eve* also be included in this category. On the other hand, the currency of the Kiss theme would have made it attractive to Brancusi, many of whose works are based on traditional, even banal, Salon themes. Indeed a certain banality may be the playful point of *The Rebuff.*[31]

But the studio conversation piece became the ur-Kiss. And the private passion that may be deduced from a close reading of the Craiova *Kiss* did more than precipitate this work; it so gripped Brancusi's imagination that he was able to sustain the theme in a number of versions, including several of architectural scope, in a meditation spanning almost four decades.

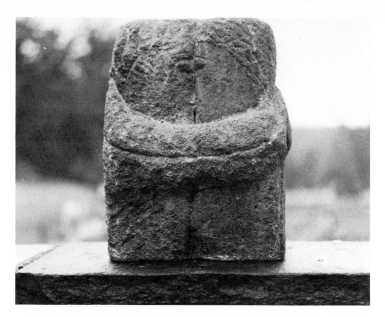

39. *The Kiss,* 1908.

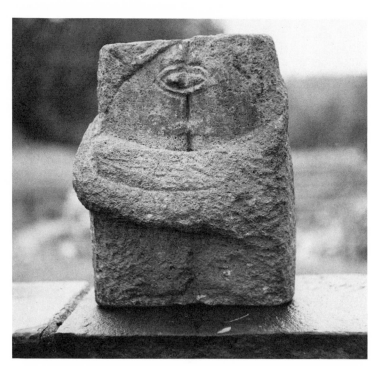

40. *The Kiss,* 1908.

Variations

It is something of a surprise, after the carefully carved Craiova *Kiss,* to encounter a second *Kiss* (Diamond Collection, New York) [39] in gray limestone that looks as though wrenched from the material. Chisel strokes are present in regions other than the hair; large areas of the coarse surface appear to have been worked by some unorthodox tool, possibly a sharp stone.

The piece has the same width and depth as the first *Kiss,* but is about an inch and a half taller; only in details does it vary the design. When viewed with the woman on the right (what I shall call hereafter the main facade), her breast does not advance on the man's chest to the same degree as in the first version; on the opposite side the treatment of the breast is unchanged [40]. The hands are tapering shapes without indication of fingers, and the hair is striated on only one facade. The groove which marks the meeting of the two bodies has the insistent depth on both sides of the sculpture that it had earlier on one.

The top is markedly concave from the loss of a large flake of stone. This condition is not visible when the viewer's eye is level with the sculpture and facing the main facade. In this view the woman is, as before, taller

47

than the man and her eye is slightly higher than his, perhaps to compensate for a hairline on the same level as his. On the other side the woman is shorter than the man because of the loss of material. The eyes here are the largest Brancusi has carved on *The Kiss;* for the first time they are rimmed with heavy lids. These staring eyes and the large unarticulated area reserved for the lips achieve a grotesque character altogether at odds with its context, and which occurs again only in *Double Caryatid* [32], carved in the same year. In contrast to the generally rough surface, one region is worked with care—the woman's hair, which is rendered by finely incised parallel lines where it falls below the man's hands.

In bringing a coarseness of facture and material to the second *Kiss* while maintaining the size and design of the first, Brancusi seems to be repeating the motif in a more obviously direct manner, manipulating the surface with typical Fauve frankness. The initial warmth and subtlety of *The Kiss* are dispelled in the brusque new version, a fact emphasized by the great expressive distance between the broad facades.

The bold handling of the second *Kiss* is accompanied by a further schematization of the design. If the work creates an impression of great immediacy, in fact of speed, that is because it had only to be executed—not invented. *Double Caryatid,* probably carved soon after, was an experiment in virtually spontaneous carving, preceded by a minimum of planning. Its facture is at once more direct and more varied than that of the second *Kiss;* like the lovers on one side of the *Kiss,* one of the caryatids has an ogreish face. Immediacy has its attractions, but at a price Brancusi does not care to pay. He will never again carve as though his chisel were responding to the moment's intuition rather than following a plan. *Double Caryatid* was not accorded the primary status of an artistic statement; it became a decorative adjunct of another work, the central element in the three-part base of *Maiastra* (The Museum of Modern Art, New York).

Although Brancusi had made a variant of a bronze piece, and had carved stone and marble versions of

works executed earlier in plaster and bronze, the Diamond *Kiss* is for Brancusi the first case of a new version in stone of an existing stone carving—a true variation on a theme. The appearance in 1909 of a second variation of *The Kiss* establishes the works on this theme as a series. The artistic series had been created before, in painting and notably by the Impressionists, but Brancusi's *Kiss* is the first case of a series of variations carried out in stone. In this same year, we note, Matisse begins his series of four *Backs,* modelled in clay for bronze; in the next year, 1910, he starts a series of five heads of *Jeannette.*

The Kiss of Montparnasse Cemetery [41] is in limestone like its predecessors, and appears to have been cut in a regular squared block, though this cannot be said with confidence of the first two versions. Slightly greater in width and depth than the Diamond *Kiss,* it is almost three times as tall, showing for the first time the full figures of the lovers.

Brancusi retains the slightly taller female and her higher hairline, but it is apparent that as *The Kiss* has grown in size both heads have become progressively longer and narrower. The arms are no longer shallow, as in the Diamond *Kiss;* their high relief "holds the plane" created by the legs. The legs themselves are a marvel of compression, establishing a sequence in depth of thigh, foot, and foot at the bottom of the work, while avoiding an impression of layers of material. In this tall *Kiss* the arms drop to a lower position on the creature they embrace, a change impelled by esthetic considerations. Since the pressure of the man's fingers is not on the back of the woman's neck, her hair falls straight down instead of following the curve of the skull as it did before. The woman's fingers, too, press the man's head at a lower point, so that now it is the curve of *his* head that shows at the rear. These latter changes, which result from the repositioning of the arms, are of a sheerly logical nature.

The new length and corporeal wholeness of *The Kiss* were accomplished by the grafting, to the canonical half-figures, of hip and bent legs, a configuration adapted from the lower part of *La Sagesse* [31] and doubled so that the legs of the man are between those of the woman.

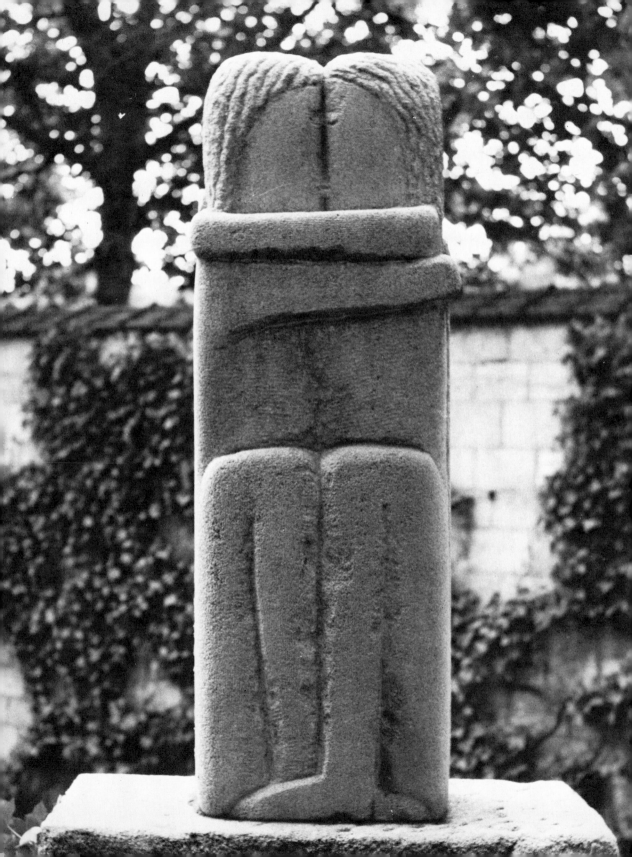

Since all but its arms are absorbed by *The Kiss,* it may be said that *La Sagesse* becomes *The Kiss.* This transformation is not merely formal. *La Sagesse* shows a shy young woman who shields her body in a gesture of withdrawal from love—in all likelihood the love of Brancusi.[1] In assimilating *La Sagesse* to *The Kiss,* which shows a couple in the act of love, Brancusi has symbolically submitted the creature of the earlier work to the act of love, an operation all the more poignant when we recall that the man in the first *Kiss* stood for the sculptor himself.

The initial innocence of *The Kiss* has given way to an image of pagan frankness. In the total embrace of the Montparnasse *Kiss* we witness a scene so sweet and stately that it is often not recognized for what it is. In all except primitive art, there is probably no representation of the sexual act that is at once so undisguised and so discreet. Although the lovers in this *Kiss* are revealed in a passional act, its intensity is mitigated by a new rigor of design and execution. The broad facades are, for all purposes, identical. The finely designed hands perform the same gesture of embracing the partner in the region of the shoulders. The hair, as before, shows a rough texture from having been worked with the point, but otherwise the sculpture exhibits a pervasive smoothness of surface and clarity of drawing from which a few tool marks and areas of chipped stone afford a quasi-accidental respite.

The design is more thoroughly rationalized than any that Brancusi has done up to this time [42], and is carried out with a precision which obscures its Fauve origins. The taut surfaces are achieved by abrasion which, in effacing the marks left by the carving tool, removes evidence of the artist's touch—the signs of process and time. Such surfaces had already been tried on the back of *La Sagesse* and the areas surrounding the cleft of *Double Caryatid.* Their expansion on the large full-figured *Kiss* adumbrates a new vision of form—as impersonal, absolute, and timeless.

On December 5, 1910, a Russian medical student named Tania Rachevskaia committed suicide in Paris as the result of an unhappy love affair with a young doctor.

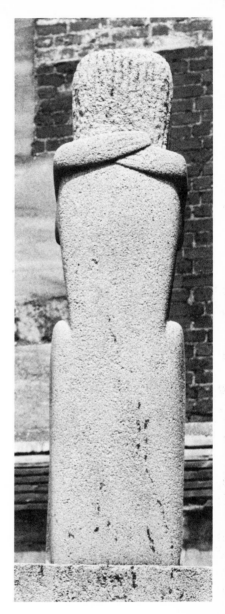

42. *The Kiss,* 1909.

51

41. *The Kiss,* 1909.

The doctor, a Rumanian and a friend of Brancusi, asked the sculptor for a work to put on the girl's grave. At Brancusi's suggestion that he take whatever he thought suitable, he chose *The Kiss* of 1909. It was placed on a tombstone whose inscription seems to have been carved by Brancusi, probably by the time of the burial, December 12;[1a] his own name is carved near the bottom of the plinth.

Margit Pogany had seen the sculpture when she first visited Brancusi in July 1910: she thought it showed "the influence of Negro art, something quite novel then." When it was installed in the cemetery, she recalled, "a great many people were shocked by it."[2] That early shock may be felt even today on seeing the Montparnasse *Kiss* in the context of the neighboring monuments.

At the Salon des Indépendants of March–May 1912, one of Brancusi's three entries was listed in the catalogue as *Le Baiser* [43], the first time the present title of the work appeared in print. This version, Brancusi's fourth, reverts to the half figures of the original *Kiss*, but with an elongation of the mass that makes the ratio of height to width greater than ever. Examined in chronological sequence, the four versions (including the half figures of the Montparnasse *Kiss*) show a gradual increase in this ratio: 1.07, 1.24, 1.5, and 1.66:1.

The new *Kiss* (Arensberg Collection, Philadelphia Museum of Art), carved in a buff-colored, dully gleaming limestone, is even more rationalized than the Montparnasse *Kiss*, with pronounced edges on the parallelepiped which governs the total mass. The top presents the most prolonged horizontal plane in the oeuvre, but one which yet is not perfectly level. Since the heads have become deeper (between the broad facades), the arms lower in their relief, and most surfaces flatter, there is no captured space between the woman's arm and the two faces above it. The narrow upper plane of the woman's arm is tipped slightly; it would shed water. The irregular striations of the hair in previous versions of *The Kiss* have been supplanted by carefully designed undulations. The work

52

43. *The Kiss*, 1912.

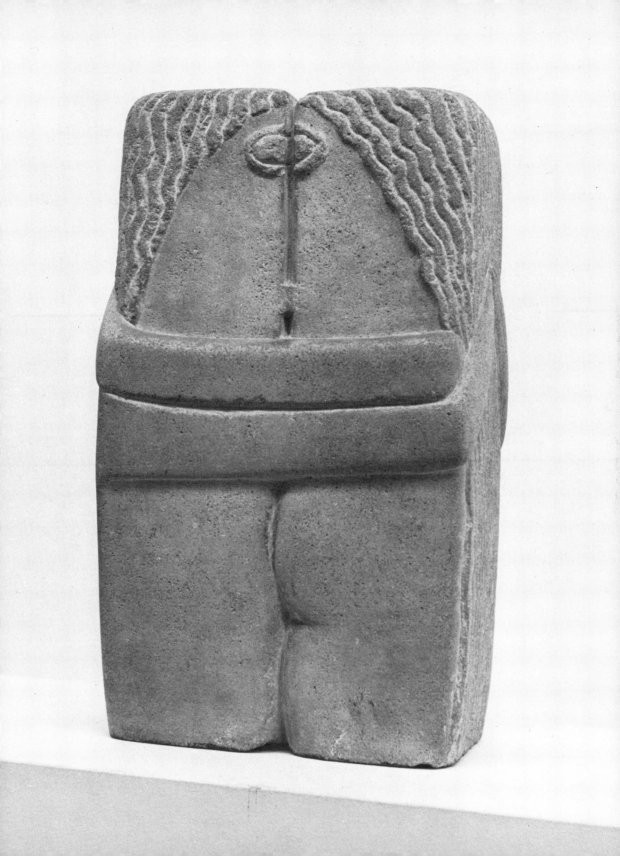

shows no other tool marks or unfinished surfaces. Given the large eyes and their closeness to each other, the increased rationalization results in the illusion, on the broad facades, of a single face looking out of the mass. As *The Kiss* evolves, the lovers approach unity.

The embracing hands form a sharp inverted V, a motif relinquished in the tall Montparnasse version but reinstated in order to animate the short space on the backs of the truncated figures. The hands, as usual, have no more than four fingers. At the back of the man's head Brancusi has omitted, in the angle formed by the woman's hands, an area of the man's hair that is present in nature. The meeting bodies are carved with great tenderness in a surprising curvature; the stone is quickened by the suggestion of organic life at its center, in touching contrast to the surrounding rigor of design.

A new fullness appears on the breasts, not in the direction of the man, but at a right angle to this, so that *The Kiss* swells slightly in the region below the arms. Observers who know the work only from photographs often think that it shows a pregnant woman, an impression that is dispelled in the presence of the sculpture. Above the arms Brancusi has introduced a curious innovation: when viewed on the main facade, the man's head is slightly in advance of the woman's head, that is, closer to the viewer. In this shift of plane, which is so subtle as not to disturb the integrity of the large mass, we see Brancusi struggling to vary the image *against* the restrictions of the large containing facades. Breast and head cannot move forward; they can only move outward, and then only slightly.

During the sale of the work to John Quinn in 1916, the artist and critic Walter Pach acted as intermediary. In a letter of October 4 of that year,[3] written to Pach in French with his characteristic phonetic spelling [44], Brancusi said:

The Kiss is a little larger than the one of which you have the cast, and a little different. I hope Mr. Quinn will be more pleased to have an original than a copy—but in any case, if

44. Part of a letter from Brancusi to Walter Pach, 1916.

there is anything that displeases him, please tell me so in all frankness, since I should not want to have anything done unwillingly. With regard to a base for The Kiss it will be preferable to put it just as it is on something separate, for any sort of arrangement would have the look of an amputation—

After the Arensberg *Kiss* Brancusi did not make another intimately scaled *Kiss* till about 1919. In the intervening years his stone carving was challenged by a great series of works in wood. When he returned to *The Kiss* it was to explore its architectural adaptation.

Probably while still in the studio at 54 Rue du Montparnasse, Brancusi started a rough plaster *Column of the*

Kiss [45] which was moved to a new studio at 8 Impasse Ronsin, where it was completed—or took definitive form—early in 1916. It has disappeared from view and is known only from photographs. Initially about 17 inches square and less than five feet tall, it was enlarged to a height of over 20 feet. Brancusi made another similar column, and for a number of years they framed a broad studio window.

The focal element of the *Column* is a stylization of the paired eyes on a facade of *The Kiss,* compressed within the scope of a circle. This circle is halved by a deep in-

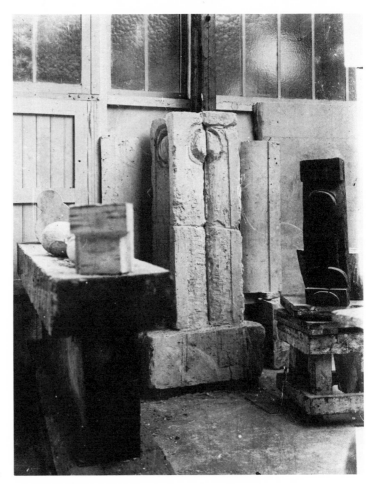

45. *Column of the Kiss,* 1916–18.

curving groove that repeats the groove on *The Kiss* which passes between the lovers, separating their opposed eyes. Nothing could better demonstrate Brancusi's deep-seated urge to transcendence than the manner in which he isolated a feature of a relatively realistic sculpture carved eight years before, and transformed it into an arresting abstract design of mysterious potency. This power is gained from an immersion in time—in Brancusi's case, time measured in years and decades, time in which the work of the imagination is tempered and tried.

Brancusi's invention is only a slight variation of a type of pilaster or decorative panel which exists since the Renaissance, and which shows, at a height of about six feet, a raised circle continuous with the moulding tangent to it

46(a). Musée du Luxembourg, c. 1900.
(b). Pilaster, Cooper Union Building, 1859.

at the sides and sometimes containing a circular convexity. Brancusi could have seen such pilasters in the Orangerie of the Luxembourg Museum [46a], a popular exhibition hall.

Essentially, he has altered the Renaissance design by introducing the deep vertical channel. This device, repeated four times on the square *Column*, and much deeper than the fluting on a Greek column, might be expected to have a disruptive effect, which, however, is not the case. The only similar deep grooving of a column in traditional architecture occurs in the carved papyrus bundle column of ancient Egypt, which Brancusi might have examined in the Louvre.

As a result of the deep grooves, Brancusi's square *Column* is composed not so much of four equal faces, as of four equal *corners* which the circular motifs have the effect of linking. Since these motifs are a stylization of the eyes of *The Kiss,* the quadripartite construction of the *Column* rationalizes the fact that both the broad and narrow sides of *The Kiss* in effect show bilateral symmetry. The result of this symmetry in two directions is that one quarter of *The Kiss,* like a quarter of the *Column,* can generate the whole by reflection. In the *Column* Brancusi sublimates the explicit male-female imagery of the first *Kiss* to create a symbol of love and union.

During these years Brancusi includes the *Column of the Kiss* in a number of drawings and gouaches of studio scenes [47]. The presence of the *Column* is indicated whenever a group of three or four parallel vertical lines appears in the background of a drawing. At a time when no stone *Kiss* remained in his studio, Brancusi had the *Column of the Kiss* daily before his eyes.

Drawings in ink on both sides of a sheet show Brancusi working on an early design for a *Gate of the Kiss;* they are among the very few by this artist that are clearly studies for a future project. A lintel shows eight pairs of lovers [48] in the attitude of those of the Montparnasse *Kiss.* But repetition and compression of the motif to planar scope call for some changes. Eliminated is the dis-

58

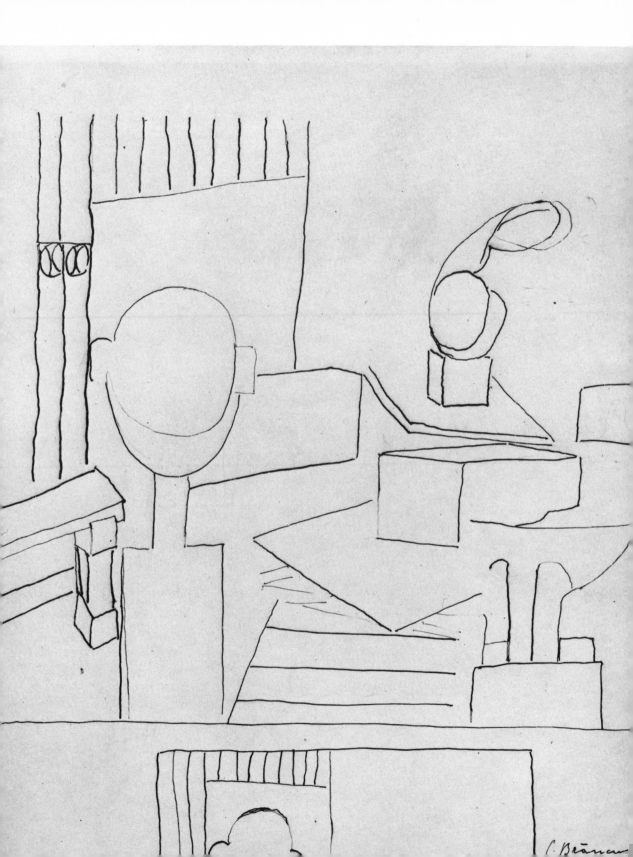

C. Brancusi

48. *Study for a Gate*, c. 1917–18.

tinction between the men's and the women's hair. A need
for symmetry has led Brancusi to indicate breasts on both
lovers. The hands, which are on the backs of the lovers in
the carved *Kiss,* are here shown on their sides; but they
trouble symmetry. The legs simplify the design of the
Montparnasse *Kiss,* but the feet cause problems. Where
will they originate? Can they overlap each other? Several
alternatives are attempted, including that of having them
spring from the thigh rather than the leg. Seemingly frus-

60

trated, Brancusi leaves a space where the feet should be on the last couple. The lintel is supported by a strange capital whose imagery resists interpretation. The column below is similar to the *Column of the Kiss,* with the suggestion that the coupled eye motif be repeated along its length. On the verso Brancusi studies only the capital. Exploratory and uningratiating as these drawings are, Brancusi thought enough of them to sign both sides of the sheet. They would seem to have been made in 1917 or 1918, for by 1919 Brancusi is on his way to solving the problem of the flat version of *The Kiss.*

In 1919 Brancusi made or began a rather shallow, pilaster-like *Kiss* of carved plaster blocks [49]. Its early appearance has had to be reconstructed,[4] but it seems to have been about 90 inches high, the largest work he had undertaken. Since it was just over 21 inches wide, the height-to-width ratio was about 4:1, making this *Kiss* relatively taller than the one in the drawing, and the most elongated that Brancusi had conceived. The arms and legs were in relief, while the strange, uncompleted face was carved in intaglio. Later Brancusi so completely reworked the piece—even hanging a mirror on it—as to make it unrecognizable as one of the *Kiss* variations.

A Kiss with two iron rings [50], made about 1919 and exhibited in New York in 1933, was entitled *Medallion* by Brancusi. The work is carved in a slab of volcanic stone just under four inches thick, two feet high, and 19 inches wide. Its flatness relates it to the recent unfinished plaster *Kiss;* it is a half inch taller than the Arensberg version [43], and the proportions of its carved front are exactly those of the Diamond *Kiss* [39].

The image here is not so much imposed on the stone as elicited from it by a sum of seemingly casual touches. With a point, Brancusi has engraved the wavy hair and chipped his way among the larger anatomical elements, relaxing his customary pride of execution. The bushing tool, while rounding an edge or unifying a plane, has left a random starring of the surface. The work is not a relief:

61

its legibility does not depend on planar illusion or the play of light. Brancusi indeed shuns illusion: since the woman's hand cannot, in the shallow depth, go around the man's head, for the first time it goes up along the head. Similarly, the man's hand is shown turning upward on the woman's back. *Medallion* is materialized from the ambiguities of a drawing on a stony surface, like a melody faintly heard on an old phonograph record.

The piercing of the stone for the iron ring has influ-

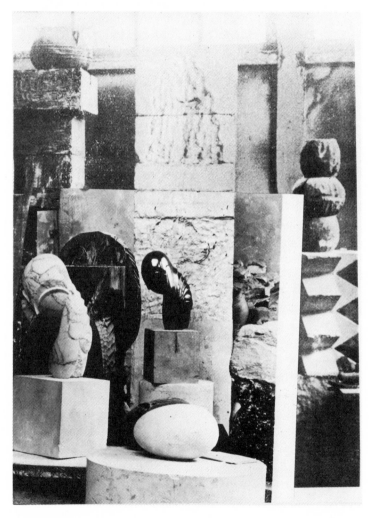

49. *The Kiss*, c. 1919.

enced the design of the eyes, reducing them to marks on the surface like many others. Motifs of clearer design or greater naturalism would be troubled by the presence of the ring. The neutralization of the eyes calls for a general abandonment of precision, and for a raising into value of the chance markings and cavities on the surface. The iron rings—the larger is about eight inches across—render *Medallion* portable, a good idea for a slab of stone carved on one side, meant to lean against a wall, and too heavy to be moved easily by grasping it with the hands.

Soon after making *Medallion* Brancusi carved a work in a rectangular slab of wood topped by an iron ring, which he also called *Medallion*. Both works, in their concreteness and the diminished esthetic distance at which they operate, call to mind Brancusi's *Cup*, 1917. The second *Medallion* is forbiddingly abstract, resembling at most a courier's bag.[5] Brancusi has sharply reduced the intensity of the imagery so that the carving may approach the objectness of the rings.

The brown limestone *Kiss* of 1923–25 (Musée National d'Art Moderne, Centre Georges Pompidou, Paris) [51], the seventh Brancusi has carved, reverts to the canonical truncated design of 1908. It is taller than the second *Kiss* by the same small amount by which the second is taller than the first. It preserves their features, but with an alteration of proportions that would result if their mass were compressed by force applied to the backs of the lovers. The Paris *Kiss* is thus relatively taller and narrower on the main facade than the Craiova and Diamond versions, and relatively deeper, this increase being communicated noticeably to the heads, whose depth is now greater than their height.

Surfaces have become fewer in number and more precise in their execution, nearing a condition—achieved long since in other works by Brancusi—of absence of *non-finito* or evidence of the chisel's working. The heads, which in the last two versions were bounded by large flat planes meeting at pronounced corners, are now designed by curved surfaces. The arms are more tautly drawn than

63

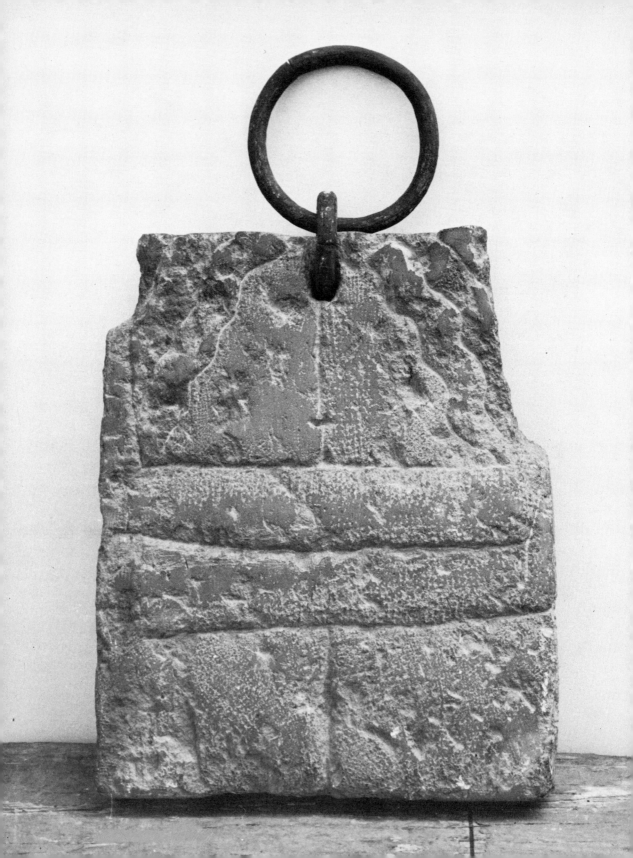

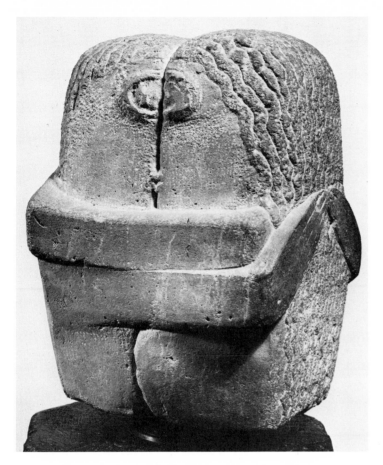

51. *The Kiss,* 1923–25.

ever, seeming to contain an internal pressure which swells the broad facades.

This bulge is fitting for the representation of the breasts; they had begun to expand in the same direction in the Arensberg *Kiss.* In the Paris *Kiss* the man's chest must share this enlargement in order not to break the rhyming of the male and female elements. The breasts, for their part, can bulge as much as they do because their differentiation from the man's chest is accomplished now by incising rather than by modelling. As always, the elements of *The Kiss* are in such tension that they can only be varied by a *quid pro quo*.

The broad facades, in any case, are only a little more

65

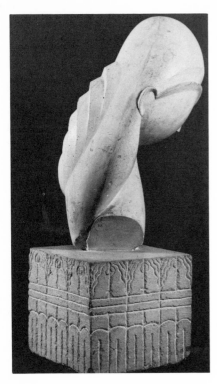

52. *Mlle Pogany*, 1919.

than a half inch (1.5 cm.) broader than the narrow ones: the oblong cross-section of the first four versions of *The Kiss* has become almost square. This squareness echoes that of the *Column of the Kiss*, 1916; it now appears too that the flat plaster *Kiss* and *Medallion* were radical variations of the *Column*.

But the Paris *Kiss* also reflects Brancusi's most recent concerns. In the same year that sees the completion of a six-foot marble *Bird in Space*, *Little Bird*, and *Beginning of the World*—all unusual spatial ventures—the arms of his lovers pass each other with a subtlety new to his treatment of the theme. But he does not forget that the woman is taller than the man, that the man's glance is bolder than the woman's, that where their lips touch two souls meet.

A planar version of *The Kiss*, essayed in the drawing of ca. 1917, appears in definitive form at an uncertain date. It is incised on two adjacent sides of a limestone base [52] which supports a plaster cast of the *Mlle. Pogany* of 1919. The features that caused Brancusi trouble in the drawing—hands, breasts, and feet—have simply been eliminated, and with no loss of intelligibility. With the elimination of the breasts—the design's last reference to gender—and abetted by the numerousness of the series, Brancusi releases an image of earthly love beyond sex. Its ambiguities permit it to be read according to the viewer's fancy; they relieve it of a specificity which would hinder its decorative function. Lace-like, limpid, the *Kiss* frieze is an invention in which wit is wedded to gravity, and simplicity to a surprising graphic richness. It can be understood at a glance, yet the multitude of expressive nuances caused by the accident of execution invites scrutiny. It seems always to have been with us, descended from some sunny meridional culture where it was distilled in untold repetitions.

The first datable example of the definitive planar *Kiss* is a drawing of October 1926 [53], made on a page of the catalogue of Brancusi's forthcoming exhibition at the

66

CATALOGUE

53. *The Kiss*, 1926.

Brummer Gallery in New York. Accompanied by an inscription, it was sent to Tarsila do Amaral and Oswaldo de Andrade, two Brazilian newlyweds—an artist and a writer—whom he had known in Paris. Typically Brancusian is the contrast of sweet drawing and tart message.

Of uncertain date, possibly c. 1930, is a drawing for a three-part sculpture whose lowest section is a block incised with the *Kiss* motif; the upper section is related to a rejected 1912 project for a fountain in Bucharest. To Anne Harvey, a young American artist living in Paris who painted his portrait in 1935, Brancusi sent a small photograph taken by himself of some flowering branches in his studio. On the other side is a cryptic though plainly sentimental message, and *The Kiss* drawn three times. Proba-

67

cette carte est fait et écrit par
moi même ainsi que mon sceau

ne pas confondre avec les cartes fait
'a la machine C.B

54. Calling card, 1937.

Constantin Brâncuși

bly related to Miss Harvey are some jewelry designs in blue crayon; one of these is a circular pendant on which the *Kiss* emblem is bordered by letters that may be an anagram of the painter's name.[6]

A shorthand rendering of *The Kiss* appears on a calling card [54] designed by Brancusi in 1937. On the verso he wrote, "This card is made and written by me and is not to be confused with machine made cards. C.B."

In the limited canon of Brancusi's drawings, the references to sculpture are few. If *The Kiss* appears more often than other works, that is because it is one of the small number of Brancusian images whose content can be transmitted in a drawing. For the draughtsman it has the additional attraction of being easy to render. Make a rectangle two and a half times higher than wide, above the middle draw three horizontals, divide the space above and below them with a vertical, add the remaining small symmetrical elements. The drawn full-figure *Kiss* generates itself, very much as the carved *Endless Column* does. Like Whistler's butterfly, it became for Brancusi a personal emblem which in later years he sometimes put at the end of a letter. There seems to be no drawing of the truncated *Kiss*.

The Kiss by its nature resists the drive toward the absolute which transforms other Brancusian themes. *Sleeping Muse, Mlle. Pogany,* and the Bird, to name the best known, all in the passage of time go beyond their beginnings, translated to other materials and unforeseen realms of meaning and design, but *The Kiss* remains constant in its humble *matière,* its stability, and its recognizable imagery, undergoing only slight change in proportion, in style, and in the sentiment these release. Brancusi was able to transform the design only by abstracting and enlarging a single feature of it, as he did in the *Column of the Kiss* [45].

While prolonging the canonical *Kiss* in an ever-growing series, he continued to meditate the symbolic columnar adaptation of 1916, and developed a tall version topped with an ambitious capital [55]. This new conception,

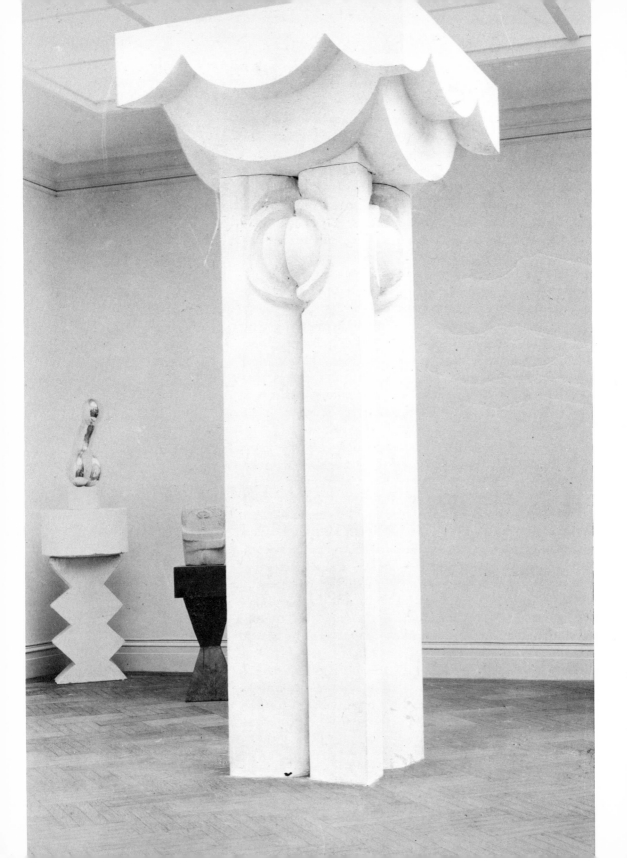

which appeared in gleaming plaster about 1930, is a sublimated abstract paraphrase of Derré's *Capital of the Kisses*, 1906 [56]. It rises to ten feet, the shaft alone measuring over eight feet. The capital, whose origins go back to 1920, has a spread of almost four feet; it is a magisterial decoration, exhibiting the perfect symmetry and inspired geometry otherwise evident only in Brancusi's bases, themselves decorations, and in *Endless Column*, an example of *haute décoration.*

In the carefully finished *Column of the Kiss,* the median groove on each face is deeper and the relief of the circular region is bolder than they were in 1916, the modelled curves of the latter contrasting with the large, mechanically achieved surfaces of the rest. The convex "eyes" bulge beyond the facades in which they lie, suggesting contained forms, and their semicircular rims have a new emphasis. It is a remarkable feature of the design that while the median groove clearly divides each face of the shaft, the circular motif succeeds in holding the halves together.

When *Column of the Kiss* was exhibited in New York in 1933–34, the catalogue entry included the notation, "Part of project for the Temple of Love." Such a temple must have been germinating in Brancusi's mind since an early date, and may be the one mentioned by H. P. Roché in a letter to John Quinn dated March 29, 1922: "Brancusi would like to build a temple, even not very big." Brancusi was not alone in this ambition. Jacob Epstein had planned a Temple of Love in 1905 when he was studying in Paris at Beaux Arts.[7] It is well to remember that at the tip of the Ile de la Grande Jatte, a week-end haven for Parisians, there stood—and still stands—a Temple of Love.

Brancusi's opportunity to erect an architectural celebration—if not a Temple—of love came in 1935 when he accepted a proposal to design a monument in the town of Tîrgu Jiu, Rumania, as a memorial to those who had fallen in its defense during the First World War.[8] He eventually created an ensemble of three works disposed

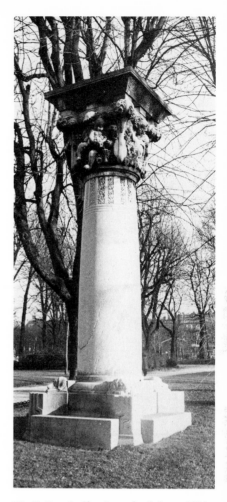

56. E. Derré, *Chapiteau des Baisers*, 1906.

71

55. *Column of the Kiss,* c. 1930.

on a west-east axis about three quarters of a mile long. The terminal pieces of this series—*Table of Silence* and *Endless Column*—were monumental versions of earlier designs, whose adaptation was accomplished *in situ* in 1937. The central structure, *Gate of the Kiss*, while employing elements which Brancusi had been developing for a quarter of a century, was a new conception. He seems to have turned to it in Paris immediately upon accepting the Tîrgu Jiu commission. Indeed, a 1934 drawing showing *The Kiss* in a series of 16—the same number as on each broad facade of the *Gate*—suggests that he may have started to work on the monument before his formal decision to undertake the task was announced in a letter of February 11, 1935.[9] A model for *Gate of the Kiss* was Brancusi's main preoccupation for the next two and a half years, a period during which only four other works—begun long before—were completed.

The *Model* [57, 58] has been dispersed, but on the evidence of its widely separated parts and two photographs, the *Gate* reproduces it faithfully except for the elimina-

57. Model for *Gate of the Kiss*, 1935–37.

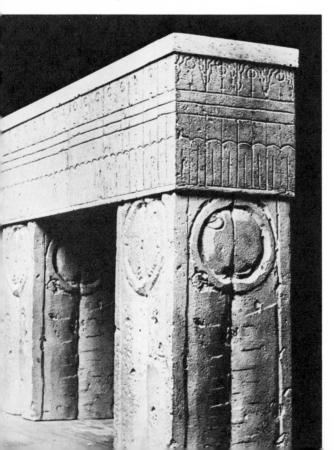

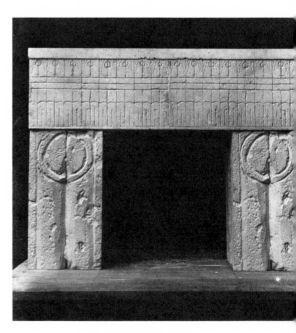

58. Model for *Gate of the Kiss*, 1935–37.

tion of two small details. The column of the *Model* was carved in limestone and then cast in plaster. For the lintel Brancusi carved a frieze of eight pairs of lovers—whether in plaster or stone is not known—which he cast twice in plaster, side-by-side. The *Model* exhibits Brancusi's customary economy of execution. It was light and demountable, and its largest part was 26 inches long, all of which facilitated its transport to Rumania. What facilitated its translation to full size was the fact that it was made in the scale of 1:10. In a country where the metric system was employed, quarrymen and masons, and the sculptor himself, had only to measure the model and move the decimal point to find a dimension on the full-scale work. There is probably no finer example in Brancusi's oeuvre of his rationalizing faculty than the *Model of the Gate,* a brilliant demonstration of his art, his attention to detail, and his total grasp of the problem at hand.

The height of the columns is by a small amount more than twice their width; they are therefore of much stockier proportions than the columns of 1916 and 1930 of which they are versions. In having the lintel rest squarely on them, Brancusi has simply by-passed the troublesome intermediate capital of the 1917 drawing [48], just as he eliminated the troublesome features of the flat *Kiss* motif in the lintel itself.

The nicety of Brancusi's calculations is discernible in the small difference between the widths of the *Kiss* couples on the broad facades and those on the ends of the lintel. The ends of the *Gate,* with only four couples on the lintel, are narrow and columnar [59]; the continuity of column and lintel is maintained by the alignment of the median cleft of the column and the median groove of the lintel. On the broad facades one would expect the same alignment to take place, since the columns are square. It does not, because the couples on these facades are slightly narrower than those on the ends. As a result of this adjustment, the eye, after moving up the column, does not continue through the lintel, but begins a new movement, as it should, across its face.

The uncarved *Gate*, a kind of blank with no presence, was ready for Brancusi in the summer of 1938; like the *Table of Silence*, it was made of *bampotoc*, a native travertine of pale ocher cast. Although the structure seems, from a distance, to be composed of three great monoliths, each column is made of at least two blocks, and the lintel is a confection of stone slabs on a supporting structure. The carving was done by an assistant, Ion Alexandrescu, from Brancusi's full-scale drawings and under his watchful eye.[10]

The *Gate* [60] is Brancusi's only work up to this time whose surfaces are decorated; and this fact, more than any aspect of the design, relates the *Gate* to Rumania's

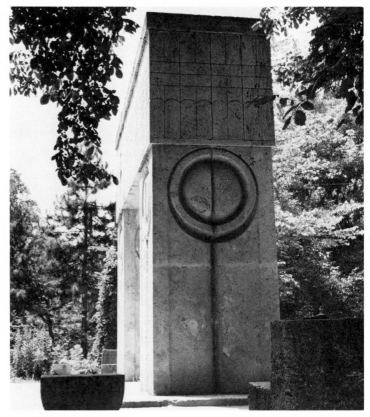

59. *Gate of the Kiss*, 1938.

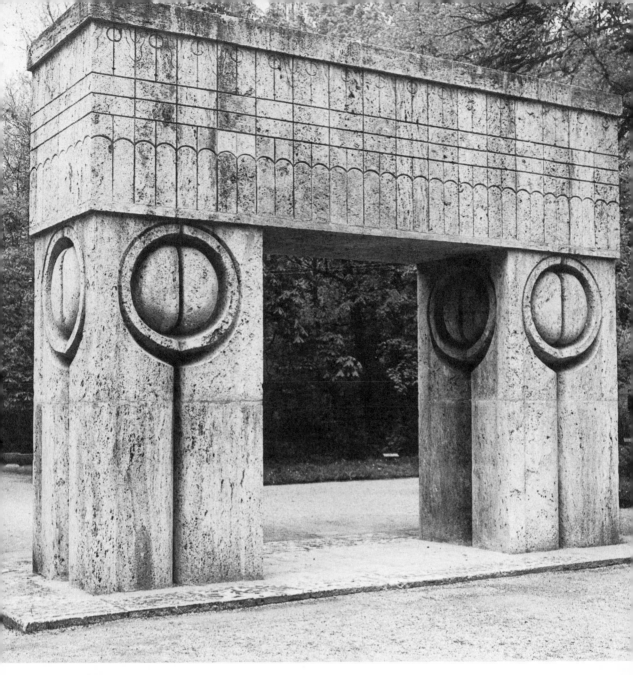

60. *Gate of the Kiss*, 1938.

much-decorated folk architecture in wood. The short square columns, despite their manifest strength, have no oppressive density; on the contrary, their in-curving surfaces invite us to consider their interiority. The circles of the "eyes" are a master-stroke in their massive orthogonal setting. Placed just below the areas of great pressure on the *Gate,* their buoyancy mitigates the blunt abutment of column and lintel. If the "eyes" are visible at a distance, giving the *Gate* a mask-like presence when seen from far off, at a close approach the population of lovers on the lintel rises to legibility, aerating the mass on which it is traced. The eight-fold repetition of the "eyes" and the forty embracing couples are not read as mere redundancy or dearth of invention. Repetition makes the *Gate* formally intelligible at a glance and in the same moment delivers its message with incantatory insistence.

The theme of the *Gate* is love and community, upheld by sexual energy. The circular motifs on the columns join the tall curved planes immediately below to make a magical image of merged male and female genitals. The inward curve of the planes and the outward bulge of the split circle above may be seen to rehearse the movement of the sexual act. When the American sculptor Malvina Hoffman visited Brancusi in the fall of 1938, on the eve of his departure for Rumania to attend the inauguration of the monument at Tîrgu Jiu, he asked her what she saw in the plaster models of the columns. "I see the forms of two cells that meet and create life," she said. "The beginning of life . . . through love. Am I right?" "Yes, you are," said Brancusi.[11]

In accepting the Tîrgu Jiu commission, Brancusi wrote to Miliţa Pătraşcu on February 11, 1935: "Now all things begun long ago come to a close, and I feel like an apprentice on the eve of getting his working papers. So the proposal could not come at a better time." The monument was the culminating endeavor of Brancusi's career. The centrality of *The Kiss* in the ensemble attests to the importance of the motif in his imagination.

Brancusi remained in Paris throughout the war years, suffering the same privations endured by his neighbors, in a studio that was glacial in winter because of the lack of fuel. It was only after the liberation of Paris that a new *Kiss* and a few other works made just before and during the war were seen for the first time.

The yellow limestone *Kiss* (Musée National d'Art Moderne, Centre Georges Pompidou, Paris) [61] reflects Brancusi's treatment of the theme on the *Gate* at Tîrgu Jiu: the rippling hair echoes the design on the lintel, and the opposed eyes achieve a circularity never so perfect in the truncated *Kiss*. After the mere hyphen of the lips on the lintel, Brancusi now eliminates altogether the feature that would seem to be indispensable to his theme. Instead he manages a slight swelling on each cheek in the region of the lips. These relieved masses, separated by a V-groove, suggest that the meeting of lips which in previous versions was visible on the surface now takes place *inside* the stone. The heads are the tallest that Brancusi has designed for *The Kiss,* here accounting for half the total height. These large heads, the absence of lips, and the shallowness of the relief all combine to cause the emphatic eye motif to stare out of the stone—at us—with an insistence that is constantly subverted by our realization that it belongs half-and-half to two creatures who face each other at a right angle to its stare.

Given the low relief of its facades and the clear corners along which they meet, the work as a whole is more massive and block-like than ever. The woman's breast, indicated by a shallow incision, has the clarity of an ideogram. Remarkable in this *Kiss* are the absolutely rigid arms. Those of the woman terminate in hands supplied for the first time with five fingers. The usual four fingers appear on the man's left hand; none are indicated on the right.

A brittle, schematic quality in the design is mitigated by the constantly changing surface. The top of the work is leveled by a bushing tool, but the strands of hair are not shown. On the main view only the woman's hair is

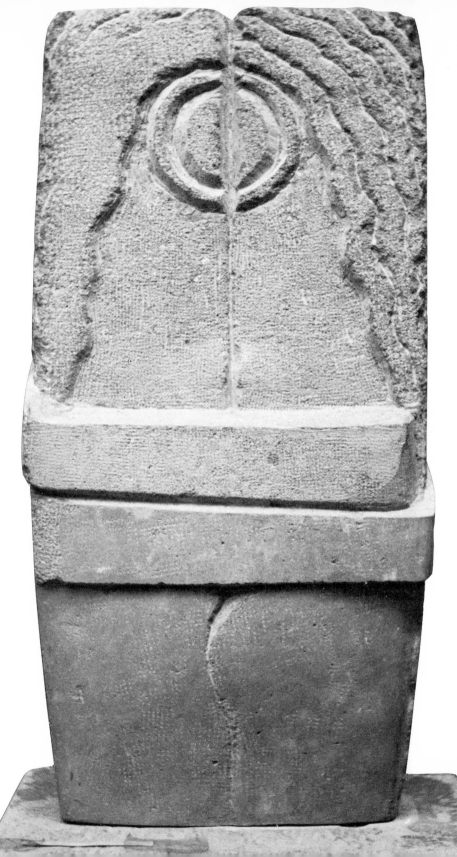

61. *The Kiss*, early 1940s.

striated. On the opposite side, facture is generally negligent, but the arms are rendered with a definition that serves to link this side with the carefully worked facade. Here the bold, even grand, design strikes a note of gentle irony.

This *Kiss* makes it clear that for Brancusi the primary view of the motif was always the one showing the man on the left and the woman on the right. It is in this view that the personal character of the first *Kiss* [45] is visible, and that the motif is unaffected by the loss of stone at the top of the Diamond version [39]. This is the view that is aligned with the inscription on the headstone in Montparnasse Cemetery [41], it is the only view which exists on *Medallion*, and the only view fully elaborated on the yellow stone *Kiss* [61].

Brancusi brings a new solution to the perennial problem of the passage of the woman's hair from her head to her back. In the Craiova *Kiss* the hair falls around the face, stops at the shoulders, and is pressed inward at the nape of the neck by the man's hands. In the Montparnasse *Kiss* a narrow band of hair falls to the woman's arms on each side of the face, while a wide band splits off and falls straight down the back in shallow relief. In the Arensberg *Kiss* the hair and shoulders lie on the same plane. In the *Kiss* of 1925 the hair ripples along the face and over the shoulders before passing under the man's hands. Although the treatment of the hair is accommodated to the other elements in each work, the formal vacillations in this series seem to be brought to resolution in Brancusi's last *Kiss*, where he rationalizes the situation and puts it into its most logical form: The hair is drawn to the back of the shoulder, where it falls in clear relief on a plane continuous with the back of the head, while the man's hands pass over it in equally clear relief. Brancusi shows us the unambiguous, layered sequence of shoulders, hair, and hands.

Yet, more than three decades after the first *Kiss*, we still find the woman slightly taller than the man, the man's

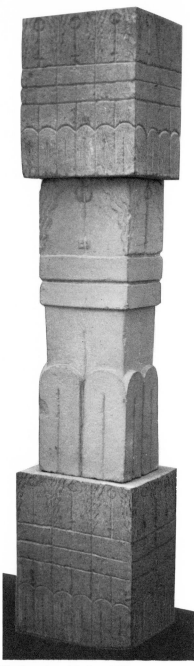

62. *Boundary Marker*, 1945.

eye slightly larger and the lower part of his face slightly broader than these features in the woman.

Brancusi continues to maintain surprising metrical relations with previous versions of *The Kiss*. The yellow stone, although five inches taller than the gray stone of 1912, varies its width and depth by one and two millimeters respectively, an insignificant amount. Upon review we find that of the five examples of the half-figure *Kiss*, the widths of the three small versions and the depths of the two large ones show an extreme variation of only four millimeters, or less than three-sixteenths of an inch. When Brancusi carves *Boundary Marker*, the last work to employ the *Kiss* motif, he reverts to the full figures of the Montparnasse *Kiss*. The new image is a half inch shorter than the original, carved thirty-six years before (see Appendix, page 95).

The metrical constancies and affinities which exist in the *Kiss* variations are to be found in the Bird and other sequences. They do not leap to the eye since the individual works are widely scattered. If they are revealed by examination, both their number and pervasiveness persuade us that they were caused by measurement. And this means that they apparently satisfied in the sculptor a need for relatedness between versions at a level other than the thematic. Metrical affinity also provided Brancusi with a necessary tension between imagination and its object, a restraint before the release of invention. Brancusi was not open to the promptings of unruly impulse.

Toward the close of the Second World War, Joseph Stalin promised the return of Transylvania to Rumania while omitting mention of Bessarabia, taken by Russia in 1940 during a brief period in which Rumania was shorn of a third of its territory. It was probably these events—the latest in a long history of the occupation of his native country by foreign armies—that moved Brancusi to make *Boundary Marker* [62].

Constructed of three separate pieces of material, the

columnar work comprises a central shaft of gray lime-stone, and a block-like capital and similar base, both of yellowish stone. The blocks are incised with the *Kiss* motif; the shaft is carved on each of its four sides with a much stylized version of *The Kiss* of Montparnasse Cemetery. Each part of the work is oblong in section. The whole work is a fraction over six feet tall, the shaft occupying less than half this height, the base being slightly taller than the capital. In showing four pairs of lovers continuously around the shaft, Brancusi has undertaken a sculptural conceit, the only one in the sculptural oeuvre. He employed a similar device on a decorated egg [63] of unknown date, where *The Kiss* is drawn four times in black on a purple ground.

In carving the lovers on the shaft Brancusi has been forced to omit the hands, as in the incised versions above and below, and to reduce the girth of the bodies, avoiding total rectangularity by tapering them. If the differing widths of front and side introduce a variation like that of the *Gate,* the treatment of the faces—alternately sunken and raised—provides a variation without precedent. *Boundary Marker* is not as distant from the viewer as the lintel of the *Gate* is; the viewer cannot be offered a simply repeated image in the intimacy of close range. Besides, the new variation has a structural justification: to have dropped the level of the faces on all sides would have left raised at each corner a wedge of hair looking as though it might be peeled or knocked off.

The flat legs and semicircular knees reduce the lower part of the figures to geometric design. The whole work, indeed, has an impersonal, almost mechanical quality, in striking contrast to the autobiographical first version. Yet this new character, with its lack of nuance and subtlety, seems to signify that *Boundary Marker* was envisioned as a project to be replicated in some number, by other hands than the artist's, for use in public places where it might be read at a glance.

The large, central, carved lovers can be discerned at a distance; up close the same image is seen to decorate cap-

63. *The Kiss,* painted on an egg.

ital and base. Thus to all—whether high or low, near or far, to the north, east, south, and west—*Boundary Marker* has one message: love. The column is Brancusi's last tribute to the country of his birth, whose landscape and song, throughout his half century of residence in Paris, haunted his memory.

In Time

The Kiss theme in Europe culminated in two totally dissimilar embodiments which appeared at the same moment: the carving by Brancusi, and the rapturous, color-drenched painting by Gustav Klimt, seen in Vienna early in 1908. In the years remaining before the outbreak of the First World War the Kiss made its appearance with diminishing frequency in the Paris Salons. During the period between the wars it had a resurgence in the art of the surrealists, but it was the preoccupation of no major artist apart from Picasso and Brancusi, both of whom had broached it long before.

The Kiss not only marked the opening of Brancusi's mature phase, it was a seminal work which exerted a continuous and various influence on the development of the oeuvre. The piece initiated, as we have seen, a long series of variations. In *La Sagesse,* which followed it, it generated its opposite: a single creature who shrinks from love. And beyond these immediate effects, it provided a point of departure for the subsequent works in stone and marble. His most stable design, carved with almost primitive simplicity in a humble material and embodying his warmest subject, *The Kiss* was a firm base from which Brancusi could venture into constructs of in-

creasingly precarious balance, carved in ever more precious materials, with a technique of progressively greater intricacy and an imagery gradually divested of incident and moving beyond the limits of figuration.

Although *The Kiss* is, indeed, the cornerstone of a major body of sculpture in our time, its special position has not been remarked, whereas the relation of the *Demoiselles d'Avignon* to the paintings of Picasso—and to much else besides—has been fulsomely commented. The reasons for this difference in reception are not far to seek. The painting is eight feet tall; while it would be arresting in any dimension, at this size it creates a disturbing, even shocking, effect. *The Kiss,* on the other hand, completed within a few months of the *Demoiselles,* is only eleven inches tall; it is an extremely gentle image, carved in a straightforward technique, whose innovations are far from being an assault on the sensibilities. But most importantly, while the *Demoiselles* was seen immediately on its completion by an appreciative group of artists and critics, and aroused discussion on all sides, *The Kiss* left Paris without having entered the arena for which it was intended.

It was first exhibited in November 1910 at the Bucharest Salon, Tinerimea Artistică, far from the ferment of the Parisian ambience. In any case, the novelty of Brancusi's direct carving style was blunted by the prior exhibition in Bucharest of *La Sagesse* [31]; this work is considerably larger than *The Kiss* and more clearly primitivizing, and when it was shown in April it had attracted a great deal of attention of different kinds. *The Kiss* was not entered in the catalogue with the Rumanian word, *Sărutul,* but as *Fragment dintr-un capitel (sculptură în piatră);* that is, Fragment of a Capital, sculpture in stone. This entry has been taken to be a reference to *The Kiss* of Montparnasse Cemetery [1]—the Craiova version being the upper *part* of the work placed *on top* of the gravestone—and all the more so since the poet Alexandru Vlahuță, writing in *Universul* on December 5, said that the sculpture showed "an embrace beyond death, in that world without time." This interpretation of the entry is

ruled out by the fact that the young woman whose grave is decorated by *The Kiss* took her life on December 7. Vlahuță's words concerning the smaller, earlier version are evidence of a poet's imagination, not a reference to the funerary use of *The Kiss* in Paris.

The wording of the entry is so unusual and specific— *capitel* has an unequivocal architectural significance—that it must have been supplied by the sculptor. Brancusi would have had two reasons for listing the work as he did. First, since he had sent the piece to Bucharest in order to avoid the risk of compromising in Paris the young woman who figures in it (pages 42–43), he gave it an architectural title to distract attention, even in Bucharest, from himself and his possible sentimental involvement in a subject entitled *The Kiss*. His second reason was that from the moment he carved the work, impelled very much by Emile Derré's *Capital of the Kisses* (page 70 and [56]), he planned to incorporate it in a similar work of his own. That work, *Column of the Kiss* [55], was finally completed about 1930; it does not show *The Kiss* in its capital, but has a stylization of the eyes of *The Kiss* immediately below the capital. The reasons for Brancusi's catalogue listing are not incompatible: the work was for him always *The Kiss* and always intended to figure on a column.

When the Craiova *Kiss* was next shown in Bucharest, in 1914, it was listed as *Sculpture in stone (fragment belonging to Mr. V. N. Popp)*. The entry repeats most of the wording of 1910; apparently no one in Bucharest had noticed that in the meanwhile two other versions of the work had been shown as *The Kiss*, nor had Brancusi troubled to write to Popp about the matter. The work was not shown as *The Kiss* in Rumania until 1943. A plaster cast was listed there as *The Kiss* in 1924; the same cast was shown in 1927 as *The Capital*, and in 1928 as *Love*.

A plaster cast of the Craiova *Kiss* (there are four) was exhibited in February 1913 at the Armory Show in New York. But it was another work of Brancusi's—*Mlle Pogany*, also in plaster—which shared with Marcel Duchamp's *Nude Descending a Staircase* the *succès de scandale*

of that occasion. *The Kiss,* however, provoked a poem which began, "He clasped her slender cubiform/In his rectangular embrace . . ." and ended, "He kissed her squarely on the lips." When the exhibition moved to Chicago the work was reproduced in a newspaper where the headline of an article announced: "Cubist Art Baffles Crowd. Soul Kiss Wins Popularity. Young Get Chance to Titter and the Old to Sigh." The article described the sculpture as "a solid block vaguely carved into two square heads with pairs of arms springing from nowhere clasped behind each head. The lips were, in the language of hectic novels, literally 'glued together.' It is undoubtedly the most passionate and lasting osculation on record."[2]

At an early date the Diamond *Kiss* [39] probably entered the collection of a lively Parisian patron of the arts, Mme Léone Ricou, only to drop out of view for two decades before entering a private collection in the United States.[3] During the Second World War, between 1941 and 1943, it was included in a traveling exhibition which visited five colleges and small museums in the United States, besides going to Honolulu. Newspaper articles in two cities listed but did not discuss Brancusi; in Honolulu he was mentioned appreciatively; the Skidmore College *News* attributed *The Kiss* to Mestrovic.[4] In 1965 it traveled again, to Washington and Hartford.[5]

Margit Pogany's account of seeing *The Kiss* of 1909 [41] in 1910 (page 52) is a record of the earliest knowledge of *The Kiss* in any version. After the shock caused by its installation in Montparnasse Cemetery at the end of 1910, it seems to have attracted little attention—although published in 1925 and 1926[6]—until after Brancusi's burial in the cemetery. Exposure to the elements for six and a half decades has left its mark on the work.

Up to the early 1960s, *The Kiss* in the Arensberg Collection [43] was the most widely known version. It was shown in Paris in 1912 when the work was listed by its present title for the first time,[7] in New York in 1922 and 1926, in Chicago in 1927, and in Moscow in 1928. In none of these places does it seem to have occasioned any pub-

lished comment, although the exhibitions themselves received much critical attention. In the exhibition hall *The Kiss* has usually charmed both the general public and the critics, the latter choosing to discuss Brancusi as a total phenomenon or singling out for comment the larger or more imposing works.

Two months after the Brummer Gallery exhibition in New York, November 17–December 15, 1926, the Arensberg *Kiss* did elicit a reaction in the press—in a form so oblique that its subject has long gone unrecognized. In the March 1927 issue of *Vanity Fair* there appeared an article titled, "Ivan Narb: Abstract Sculptor of the Cosmic." (Narb: read it backwards.) The subtitle went: "His esoteric aesthetique explained so that even you can understand it." The author was given as "Gwendolyn Orloff." Regular readers of the magazine must have been aware that the actual author was E. E. Cummings, a contributor who had resorted to pseudonyms before.

The piece was not Cummings' first to deal with Brancusi. As an undergraduate in 1915 he had mentioned *Mlle Pogany* approvingly in *The Harvard Advocate.* In an article in *The Dial* in 1920 he wrote that in *Princess X,* shown in New York in 1917, Brancusi had done "something more than exciting." But Brancusi's new work causes a sharp change in his attitude: "Judging from the recent bumps and buttons at the De Zayas Gallery he is at present as dead as a doornail." [8]

The *Vanity Fair* piece lampoons the adulation of collectors and the language of critical acclaim that Brancusi's sculpture had aroused. Cummings, who had a flair for painting in a style of relaxed naturalism, was not going to be taken in by the "cosmic" pretensions of a Brancusi cult. But the Orloff-Cummings rage against snobbism and mystification was so intense that it consumed the poet's real wit and rendered unfunny an article surely intended to produce laughter.

The article was illustrated with drawings of two works described as "miracles of modelling exclusively reproduced on this page by kind permission of the artist." The drawings are by Cummings. One of them is highly fan-

64. E. E. Cummings, Caricature of *The Kiss*, 1927.

ciful, a facile parody of "modern art" which seems to have been inspired by *Mlle Pogany*. The other is a rendition of *The Kiss* [64] with the rubric, "Hatlessness. In this arresting sculpture, Narb has successfully battled with the problems of a fatally plastic ambiguity."

A photograph of *The Kiss* of 1912 was reproduced in a handsome catalogue which was on sale at the Brummer Gallery. But if Cummings thought the work ridiculous, it is not likely that he would have bought the catalogue, and we may suppose that when he got around to drawing it, he did so from memory, producing a rather realistic—if Art Deco—version which is far less extreme than the object of his ridicule. Cummings reinstates all the features Brancusi eliminated: a nose, an ear, a chin, eyebrows, and an arm bent at the elbow—not to mention the lower parts of the two bodies. With the bent arm he has reintroduced the traditional problem of the visibility of the woman's arm, and by dropping the arms from their position on the sculpture has created a problematic space between chin and shoulder. It is difficult to consider Cummings' alterations as intentional—in his *Dial* article several years earlier he had remarked on Brancusi's "elimination of unessentials." His alterations would seem to indicate that while viewing the sculpture, Cummings succumbed to its magic; back in his studio he gave it all those features that Brancusi's art had been able to dispense with, but whose absence had gone unnoticed. Cummings thought of himself as a unique witness, but his memory of *The Kiss* was, in the end, like that of most observers.

Because of its presence in a famous collection, the 1912 *Kiss* has been seen in many exhibitions, has traveled to Montreal, Tokyo, and London, and been reproduced with great frequency in art books and journals, especially in the United States. It figured on the cover of a manual of advice on sexual matters distributed to students registering at Yale in 1970 (re-issued in 1975);[9] the manual was published in a paperbound trade edition in 1971, again with *The Kiss* on the cover. It was reproduced during a magazine subscription campaign of national scope in 1972; it decorated the invitation card of an important exhibition of sculpture at the Tate Gallery, London, in 1973, and that winter appeared on a popular Christmas card. The sculpture may be on the way to suffering the same

over-exposure that Rodin's *The Thinker* experienced in the early part of this century.

Since Brancusi's death in 1957 and the reconstitution of his studio at the Musée National d'Art Moderne in 1963, the versions of *The Kiss* in brown and yellow stone [51, 61], as well as *Medallion* [50] and *Boundary Marker*[10] [62]—all left in the studio by the sculptor—have been seen there by a great number of visitors as Brancusi's fame continues to grow. With the studio reassembled at the Centre Georges Pompidou, this number is sure to increase.

The first *Kiss* had to wait over fifty years before becoming available to a large public. In a series of exhibitions held between 1961 and 1970 it was seen in Paris, Vienna, London (where it was reproduced on the catalogue cover), Philadelphia, New York, Chicago, Bucharest, and The Hague, belatedly acclaimed on all sides and entered into the canon of the key works of early modern sculpture. In 1967 it received the ultimate contemporary accolade by its inclusion in a series of Rumanian postage stamps devoted to works by Brancusi in his native country. But whatever its public record may be, this *Kiss*—the tenderest version of Brancusi's tenderest theme—has an intimate appeal to the viewer, whom it attracts by spiritual force.

Although the first *Kiss* has enchanted Rumanians for decades and great numbers recently in other parts of Europe and in America, it cannot be said to have left its mark on History, unlike *The Prayer* of 1907 [2] which, when exhibited in 1910, immediately altered the careers of Lehmbruck and Archipenko. Any influence of *The Kiss* on the course of modern sculpture was effected by its later versions, which probably reinforced a tendency to direct carving that in any case did not become widespread until the 1920s. Curiously, the theme was to appear in the oeuvres of four sculptors whose lives touched Brancusi's. Wilhelm Lehmbruck, whose *Kneeling Figure*, 1911, was much indebted to Brancusi's *The Prayer*, shown at the 1910 Salon des Indépendants, in 1918 mod-

elled a *Liebende Köpfe* which is essentially a Kiss. Julio Gonzalez, who had been close to Brancusi in Paris during the First World War, did a small abstract relief in iron, *The Kiss* [65], in 1930; its protagonists, indeed, are represented by two interpenetrating ovals which also echo Brancusi. William Zorach, who had written a long article

65. J. Gonzalez, *The Kiss*, 1930.

on Brancusi after the latter's arrival in New York early in 1926, modelled two life-size lovers in his *Embrace* of 1933. And Isamu Noguchi, who had assisted Brancusi in 1927–28, carved an alabaster *Kiss* in 1947 which shows two stylized heads. Poets have for long been inspired by the sculpture of Brancusi, and occasionally by *The Kiss*. Ernst Jandl's typographic work on the theme is especially felicitous:

ja ja
ja ja
ja ja
ja ja
 ja
ja ja
ja ja
ja ja
ja ja

As legend accumulates around the person and art of Brancusi it becomes necessary to examine an interpretation of the Montparnasse *Kiss* which has acquired a disturbing currency among some devotees of the sculptor; namely, that Brancusi carved it to show two lovers joined even in death, the bent legs on each side of the work forming the letter M—for *Mort*.[11] Yet we have Margit Pogany's clear report that she saw the work in Brancusi's studio in July, five months before its installation—of which she was also aware—in Montparnasse Cemetery on the grave of the lovelorn young woman who took her life early in December 1910.[12] There is, besides, the caption of a photograph of the work which appeared in the article on Brancusi by William Zorach in the March 1926 issue of *The Arts*. It reads: "Now in Montparnasse Cemetery, although not originally intended as a memorial." The photographs and everything of a factual nature in Zorach's excellent article were surely supplied by Brancusi himself, who had arrived in New York on January 20 to attend a small exhibition of his sculpture at the Wildenstein Galleries.[13] The statement was not made to quell

a controversy, since there was none at the time; it is likely that Brancusi made the point in passing while talking with Zorach. There is also a photograph of this *Kiss* dated 1909 in the sculptor's hand.[14]

Contrary to this clear evidence is Brancusi's statement—made to an interviewer when he was almost 81, forty-seven years after the work was carved—that *The Kiss* had been commissioned for the grave of a "married couple," had been designed to include the letter M, etc. This tale shows the aged and ailing sculptor to have succumbed to the suggestion of an over-imaginative exegete.

Gate of the Kiss, in its turn, has been interpreted as the logical symbol of union, ∪, albeit upside-down. Though Brancusi's mind was complex enough, nothing that we know supports an intricacy of this kind. It cannot be demonstrated that his work at any point shows a preoccupation with the esoteric, with arcane systems of thought, with numbers, tantras, signs, or symbols. The Brancusian imagination, at its most opaque and ambiguous, always springs from the actual.

And it maintains a surprising relevance to the actual, a chameleon timeliness that belies its "timelessness." Whereas *The Kiss* seemed "passionate" in Chicago in 1913, its eroticism now seems orderly, cool, pleasantly mild, and closer to the attitudes of young people today than is, for example, the abrasive sexuality of the *Demoiselles d'Avignon*. *The Kiss* in yellow stone achieves— in the male-female mask which stares out at the spectator—an androgyny that has become the subject of recent discussion of sex. No other Kiss, of any epoch, is in closer accord with contemporary feminist thought. Brancusi's lovers embrace in perfect equality, displaying neither domination on one side nor submission on the other. Their relationship reflects Brancusi's politics, since there is no doubt concerning his progressivist sympathies in the period before the First World War.[15] From this point of view his *Kiss* is corrective of the work of the socialist Derré [27] in which the man is shown dominat-

ing the woman. But Brancusi's egalitarianism succumbs to a pervasive semantic tradition: in preferring the male on the left and the female on the right (page 79), he preserves the sequence in phrases like "man and woman," "husband and wife," "Mr. and Mrs.," and Joyce's sententious "the he and the she of it."[16] Insights gained from recent studies of communication lead to new understanding of the immediacy with which *The Kiss* is apprehended. In *The Kiss*, as we have noted, the broad facades are similar and virtually symmetrical, and so are the narrow ones. We have also noted the speed with which the work is grasped, a speed which is, if anything, even greater in many later works. It is these two factors which are related in a formulation indebted to information theory: "the greater the redundancy, the faster the flow of the experience."[17]

The Kiss in any case is immersed in time—by its material, its subject, its expression, and its repetition over almost four decades. Every previous sculpture of Brancusi's had been particular in its representation and thus in its temporality. *The Kiss* entered a new temporal dimension not by a blurring of focus, but because—*pace* Cummings—it was conceived under the sign of the cosmic.

66. *Sleeping Muse*, 1909–10.

94

Its repetition is not investigatory, like the *Haystack* series of Monet, or obsessional, like Jawlensky's *Heads*. Obsession is ruled out by the very number of the themes pursued by Brancusi: *The Kiss, Mlle Pogany,* the Bird, *Sleeping Muse, Endless Column, Cup, The Cock, White Negress*. These series are reveries. *The Kiss,* the first of them, induces revery in the viewer; in the sculptor it sustained a revery that lasted thirty-eight years. We recognize the psychology of revery to be that of Brancusi: the necessary sense of well-being of the dreamer, and his beautifying of the object of his dream.[18] It is in revery that Brancusi attains the cosmic; the dreamed cosmos is outside of chronological time. The sculptor-dreamer while he works does not count the time. In his work time stands still.

The revery of love leads to a revery of the beloved—*Sleeping Muse* [66]—whose features we know from those on the first *Kiss*. Beyond the encounter of two personal lovers in this *Kiss,* we may see the embrace of the artist and his inspiration. Brancusi pays homage to his Muse with a kiss, and she consecrates him as Sculptor in the same kiss. If, in the long career that followed, Brancusi's ideas on the relation between art and love, like that between men and women, would undergo change, *The Kiss* holds in suspension the imperishable moment when art and love were one.

Appendix:
The Measurements
of <u>The Kiss</u>

			height cm.	width cm.	depth cm.
1907–08	Craiova *Kiss*	(a)	28.0	26.1	21.8
1908	Diamond *Kiss*	(b)	31.7	26.0	21.5
1909	Montparnasse *Kiss*	(c)	89.5	29.7	22.7
	upper part of (c)	(d)	45.5		
1912	Arensberg *Kiss*	(e)	58.4	35.1	26.1
c. 1919	*Medallion*	(f)	59.5		
1923–25	MNAM brown *Kiss*	(g)	36.5	25.7	23.8
c. 1940	MNAM yellow *Kiss*	(h)	71.8	35.2	25.9
1945	shaft of *Boundary Marker*	(i)	88.5		

As the height of *The Kiss* changes, the other dimensions are conserved. The three small canonical versions (a, b, g) increase in height from 28.0 to 31.7 to 36.5 cm. But the width and depth of the first two are virtually identical, while the third varies significantly from the others only in depth, and then only by about two centimeters, or less than an inch.

In the two larger versions of the truncated *Kiss* (e, h), although the height of the second is noticeably greater than that of the first, the width and depth of both are for all purposes the same, and the depth of both conserves the width of the three shorter versions.

96

The Montparnasse *Kiss* is the tallest of all versions of the theme. But the part above the knees (d), which would constitute a truncated *Kiss,* is about 45.5 cm. high; that is, taller than the three small versions, and shorter than the two large ones.

Omitting *Medallion,* the seven heights, (a) to (h), arranged in ascending order, are remarkably close to constituting a curve which is one of a group known as transcendental curves.

Medallion is only a centimeter taller than the Arensberg *Kiss,* which it follows. The central shaft of *Boundary Marker,* 1945, showing a quadrupled *Kiss,* is a centimeter shorter than the Montparnasse *Kiss,* 1909, whose design it resembles.

Notes

Theme

1. W. Tucker, *The Language of Sculpture,* London, 1974, p. 135.

2. As this manuscript was in the course of publication, two texts on *The Kiss* appeared: E. Güse, "Brancusis Kuss-Motiv: Eine Präzisierung seiner Bedeutung," *Constantin Brancusi,* Duisburg, 1976, pp. 100–115; and I. Pogorilovschi, *Comentarea capodoperei,* Jassy, 1976, where, in a discussion of the ensemble at Tîrgu Jiu, there is an examination of aspects of *The Kiss.*

3. From a statement made by Brancusi, December 1956; B. Urbanowicz, *Przeglad Artystyczny,* Warsaw, July 1957. Quoted in B. Brezianu, "The Beginnings of Brancusi," *Art Journal,* XXV/1 (Fall 1965), p. 22.

4. "Ce-aş fi putut face mai mult decît Rodin şi la ce bun?"; Şt. Georgescu-Gorjan, "Mărturii despre Brâncuşi," *Studii şi Cercetări de Istoria Artei,* tome 12, v. 1 (1965), p. 71.

5. When André Salmon, a friend of Brancusi, wrote the sculptor's entry for E. Bénézit, *Dictionnaire des Peintres, Sculpteurs, Dessinateurs et Graveurs,* Paris, 1949, v. II, 101–102, he named seven carvings, designating *The Kiss* in unique fashion: "Le Baiser (taille directe)." But *all* the carvings Salmon mentions are examples of *taille directe.*

6. For the two copies, see the catalogue of S. Geist, *Brancusi: The Sculpture and Drawings,* New York, 1975, pp. 175–176, nos. 42 and 52. For the four related works, see nos. 43, 50, 51, and 53.

7. B. Brezianu, *Opera lui Constantin Brâncuşi în România,* Bu-

charest, 1974, p. 128. An English edition of this work, *Brancusi in Romania,* appeared in 1976.

8. A. C. Tacha, a review of *Brancusi* by I. Jianou, *The Art Bulletin,* XLVI/2 (June 1964), p. 261.

9. The work is actually dated "190 ," that is, with the fourth number missing. Since Brancusi stopped modelling in 1907 and began direct carving with *The Kiss* (see quotation on p. 8), which was surely completed early in 1908, *Première pierre directe* is taken to precede it, and is given the 1907 date.

9a. This work is listed as *Wisdom of the Earth* in Geist, 1975, p. 176, no. 56. For change of title, see S. Geist, *"La Sagesse* or *Cuminţenia pămîntului?" Constantin Brancusi,* Duisburg, 1976, pp. 90–99.

10. There are some nine works which exist only in plaster versions, having been modelled originally in clay or plaster. But the source of these was in every case a carving.

11. *"Elle avait été, disait-il, son chemin de Damas. Pour la première fois, il y avait exprimé son essentiel;"* H. P. Roché, *"L'Enterrement de Brancusi," Homage de la Sculpture à Brancusi,* Paris, 1957, pp. 26–29. The conversation took place late in Brancusi's life, while he and Roché were looking at *The Kiss* in Montparnasse Cemetery. Brancusi thought of his series as if they were single works, often giving them the date of the first appearance of the motif. It is assumed here that *The Kiss* in its first (Craiova) rather than its third (Montparnasse) version was Brancusi's "road to Damascus."

12. In a letter of December 7, 1920, to John Quinn, Brancusi wrote, with special concern for *Torso,* onyx (Fogg Art Museum, Cambridge): "It must be understood that all these works are conceived directly in the material and made by me from beginning to end, and that the work is hard and long and goes on forever;" John Quinn Collection, Manuscript Division, New York Public Library. After proposing to design a monument for the grave of a Rumanian poet in 1938, Brancusi, when pressed for a sketch of his project, said, "I don't work from sketches, I take the chisel and hammer and go right ahead;" B. Brezianu, "Brâncuşi şi Transylvania," *Tribuna,* February 24, 1966.

13. The quotation is from a letter written in 1952 by Margit Pogany to Alfred H. Barr, Jr.; S. Geist, *Brancusi: A Study of the Sculpture,* New York, 1968, p. 191.

14. Only the twisting *Mlle Pogany,* 1912, and *Caryatid,* 1915, and *Adam,* 1921, with their elaborate backs, present views which cannot be anticipated.

15. Reproduced in N. J. Perella, *The Kiss Sacred and Profane,* Berkeley and Los Angeles, 1969, pl. 20.

16. Ibid, pl. 18.

17. R. Rasmussen, *Art nègre,* Paris, 1951, cover illustration.

18. The object reproduced, and information concerning it, were given to the author by Aracy Amaral, São Paulo.

18a. S. Geist, "Maillol/Derré," *Art Journal*, XXXVI/1 (Fall 1976), pp. 14–15.

19. P. Jamot, "Les Salons de 1906," *Gazette des Beaux-Arts*, tome 36, 1906, p. 54.

20. See S. Geist, *Constantin Brancusi, 1876–1957: A Retrospective Exhibition*, New York, 1969, p. 61; also Geist, 1975, p. 19.

21. Stated in a letter from Daniel Kahnweiler to the author, October 17, 1963 (see Geist, 1968, p. 210); Brancusi archive, the Library of The Solomon R. Guggenheim Museum, New York.

22. Derain seems to have drawn heavily on an antecedent work, itself the product of a series of influences.

23. The term was proposed by the author during a public discussion following a lecture on Matisse's sculpture given by Albert Elsen at the New York Studio School on January 30, 1968.

24. Noted by W. Hofmann, "Über Matisse, Maillol und Brancusi," *Museum und Kunst: Beiträge für Alfred Hentzen*, Hamburg, 1970, p. 102.

24a. "Im Herbst 1907 entstehen zwei Steinskulpturen, von denen die eine [. . .] eine stehende Frau darstellt, während die andere einen Kauernden menschlichen Körper in die geschlossene Form des Würfels gieszt"; Daniel Henry [Kahnweiler], *André Derain*, Leipzig, 1920, p. 10.

25. Cosmutza's articles appeared in nos. 3 and 19, 1908. Morice's article, dated December 1908 in Paris, appeared in *Luceafărul*, no. 5, 1909; he wrote: "The sculptor Constantin Brancusi, well-known and highly regarded, is one of the most gifted artists of his generation."

26. C. Mauclair, *Servitude et Grandeur littéraires*, Paris, 1920, p. 20.

27. This is not to propose that Brancusi read Morice's elaborate work or, indeed, that he was a great reader. What one may examine of his library at the Musée National d'Art Moderne—with many of its books cut only in the opening pages—suggests the opposite. In this respect see also the testimony of Brancusi's friend, the musician Mihai Mihailovici; N. Argintescu-Amza, *Expresivitate, Valoare şi mesaj plastic*, Bucharest, 1973, p. 244. But if Brancusi opened Morice's book at all, he would easily have been led to the page cited here, a key passage in the volume. (Brancusi's library is not as he left it; many of his books and papers were stolen before the transfer of the studio to the Musée.)

28. A photograph of *Pride* is inscribed in Brancusi's hand, "*Tête d'expression, École des Beaux-Arts;*" personal archive of B.

Brezianu, Bucharest. Brancusi enrolled at the Ecole on June 23, 1905; Brezianu, 1974, p. 17.

29. Reproduced in B. Brezianu, "Iconografie brâncuşiană," *Tribuna*, Cluj, February 24, 1966.

30. M. Tabart and I. Monod-Fontaine, *Brancusi photographe*, Paris, 1977, pl. 2.

31. The five carvings besides *The Kiss* are nos. 54, 59, 65, 71, and 84; catalogue of Geist, 1975. There is no record of the exhibition of nos. 54 and 65, although both were published in the 1920s.

32. The head of the man in *The Rebuff*, while resembling Brancusi, is clearly anthropoid; the author described him as "a rather beastly man," in Geist, 1968, p. 19. It is altogether likely that the apelike appearance of the man is a reference to two notorious works by Emmanuel Frémiet (1824–1910): *Gorilla Carrying Off a Woman*, 1887, and *Orang-utang Strangling a Native of Borneo*, 1895. The former was exhibited at the Exposition Centennale, 1900, where Frémiet was awarded a *grand prix*. The latter was acquired, c. 1905, by the Jardin des Plantes where it may still be seen. A drawing, by K. Wagner, shows a gorilla lecturing over the supine body of a naked woman, in *L'Assiette au Beurre*, no. 262 (April 7, 1906).

Variations

1. See Geist, 1976.

1a. The date of the death of Tania Rachevskaia is from a copy of the coroner's report, issued to the author at the Mairie of the XV Arrondissement, Paris, September 15, 1965; the date of burial is from the Cimetière du Sud, the "Montparnasse Cemetery"; letter to the author, October 10, 1964. Both documents are in the Brancusi archive, the Library of the Solomon R. Guggenheim Museum, New York.

2. Geist, 1968, p. 190.

3. In the John Quinn Collection, Manuscript Division, New York Public Library.

4. Our photograph is composite. The upper part is a detail of a photograph of 1925; *This Quarter*, no. 1, 1925, pl. 15. The lower part appears in a photograph of 1920, probably early in that year; *The Little Review*, Autumn 1921, pl. 6. See Tabart and Monod-Fontaine, 1977, pls. 40 and 13.

5. Reproduced in Geist, 1975, p. 186, no. 139.

6. These drawings are, respectively, in the Brancusi Bequest, Musée National d'Art Moderne, Centre Georges Pompidou, Paris, and a private collection, New York.

7. The letter is in the John Quinn Collection; the same letter

details Picasso's architectural ambitions. Epstein's plans are mentioned in R. Buckle, *Jacob Epstein, sculptor*, London, 1963, p. 18.

8. The following discussion is based on S. Geist, "Brancusi: The Centrality of the Gate," *Artforum*, October 1973, pp. 70–78.

9. The drawing is published in Brezianu, 1974, bookjacket. The letter of acceptance; S. Geist, "Looking for Brancusi," *Arts*, 39/1 (October 1964), p. 54. If Brancusi was not projecting the *Gate* in making the drawing of sixteen pairs of lovers, it nevertheless was useful for the *Gate* design, by a coincidence of a kind that seems to occur again and again in Brancusi's career.

10. For the charming account of this relationship, see I. Alexandrescu, "Mărturiile unui cioplitor," *Ramuri* (Craiova), March 13, 1965.

11. M. Hoffman, *Sculpture Inside and Out*, New York, 1939, p. 53.

In Time

1. Brezianu, 1974, p. 118. See the same work, pp. 119–120, for a very full bibliography on *The Kiss*. For a discussion of the critical reception in Bucharest of *La Sagesse*, see B. Brezianu, "Brâncuşi în cultura şi critica românească, 1898–1914," *Pagini de artă modernă românească*, Bucharest, 1974, pp. 59–106.

2. The poem is quoted in A. Saarinen, *The Proud Possessors*, New York, 1958, p. 215. The newspaper article appeared in the *Chicago Daily Tribune*, March 25, 1913.

3. The early history of the Diamond *Kiss* is not known. Georges Oprescu, "Un Chapitre peu connu de la vie sociale et artistique du Paris de la 'Belle Époque'," *Gazette des Beaux-Arts*, July 1967, pp. 121–124, mentions a *Kiss* in the collection of Mme Léone Ricou. A stone *Kiss* is recorded in the collection of A. Bogdan Piteşti, Bucharest, in 1923, after which the work disappeared; Brezianu, *Opera*, 1974, p. 239. The Diamond *Kiss* could be one of the two mentioned above. It was bought in 1936 from the art dealer, Pierre Loeb in Paris, by Mrs. Stanley Resor, Greenwich, Connecticut, on the recommendation of Alfred H. Barr, Jr.; letter of A. Barr to the author, September 22, 1966, in the author's files. It was later acquired by her daughter, Mrs. James Laughlin, Norfolk, Connecticut. In 1972 it was acquired at auction in the Parke-Bernet Galleries of New York by Mr. and Mrs. Harold Diamond, New York.

4. The exhibition, circulated by The Museum of Modern Art, New York, was called, "20th Century Sculpture and Constructions." A record of the exhibition, with press clippings, is available at the museum.

5. The exhibition was called "20th Century Painting and Sculpture"; it was held at the Washington (D.C.) Gallery of Modern Art and The Wadsworth Atheneum, Hartford, September–December 1965.

6. *This Quarter*, no. 1, 1925, pl. 31; and W. Zorach, "The Sculpture of Constantin Brancusi," *The Arts*, IX/3 (March 1926).

7. Brancusi's three entries in the Salon des Indépendants of 1912 were listed in the catalogue as: "494 Muse endormie," "495 Prométhée," "496 Le baiser." It is certain that *Prometheus* was carved after *Sleeping Muse,* and it is assumed that this *Kiss* follows *Prometheus.* The assumption that Brancusi's listings in Paris Salons of three or more objects are in chronological order appears to be supported by his catalogue entries (3 works) for the Salon D'Automne, 1906, and (4 works) for the Société Nationale, 1907. In the catalogue of the Armory Show, New York, 1913, Brancusi's entries observe chronological order in the first four items; the fifth item is out of order—but it was not submitted by Brancusi, but by an American collector. The Arensberg *Kiss* was acquired from Brancusi by John Quinn in 1916. It was among the works from the Quinn Collection acquired after Quinn's death in 1924 by Marcel Duchamp and H. P. Roché, from whom it was acquired by Walter Arensberg in 1932.

8. *Mlle Pogany* was mentioned in "The New Art," *The Harvard Advocate,* June 1915. "Bumps and buttons" probably refers to *Penguins* (Philadelphia Museum of Art); the article was "Gaston Lachaise," *The Dial,* February 1920. These articles and "Ivan Narb" were reprinted in E. E. Cummings, *A Miscellany Revised,* edited by G. Firmage, New York, 1965.

9. *Sex and the Yale Student,* New Haven, 1970. An article on the booklet and a reproduction of the cover were published in *The New York Times,* September 17, 1970; the cover was published again in the same newspaper on April 28, 1971. A trade edition of the booklet, *The Student Guide to Sex on Campus,* New York, 1971, reproduced *The Kiss* on its cover.

10. *Medallion,* ca. 1919, appears in a photograph of 1920; Tabart and Monod-Fontaine, 1977, pl. 15. *The Kiss,* 1923–25, brown stone, appears in a photograph of 1923 in the Brancusi Bequest, Musée National d'Art Moderne, Centres Georges Pompidou, Paris. The work is inscribed "1925." *The Kiss,* early 1940s, yellow stone, first appears in photographs at the end of the Second World War; Brancusi archive, the Library of The Solomon R. Guggenheim Museum, New York. *Boundary Marker,* 1945: the earliest text which dates the work is André Salmon's entry on the sculptor; Bénézit, 1949, II, p. 102.

11. B. Urbanowicz, "Vizita meă la Brâncuşi—Decembrie 1956," *Colocviul Brâncuşi,* Bucharest, 1968, pp. 108–110.

12. For a full account of this episode, see B. Brezianu, "Le Secret du 'Baiser' de Brancusi," *La Revue du Louvre*, no. 1, 1969, pp. 25–30.

13. Brancusi showed eight works at the Wildenstein Galleries, New York, February 21–March 3, 1926. He was in New York c. January 20–c. March 24, 1926; Geist, 1968, p. 205.

14. In the collection of the painter J. Le Moal, Paris.

15. According to Güse, 1976, p. 111, the content of *The Kiss* is "socialistic, in a general sense." Pogorilovschi, 1976, p. 192: *La Sagesse* "represents, clearly and distinctly, man as a generic creature"; by contrast, *The Kiss* is a "sign of the persistence of man."

16. *Finnegans Wake*, 213.12.

17. R. Ornstein, *On the experience of time*, Baltimore, 1970, p. 49.

18. On revery, see G. Bachelard, *La Poétique de la rêverie*, Paris, 1960, especially Chap. V: "Rêverie et cosmos."

List of Illustrations

1. Constantin Brancusi. *The Kiss*, 1907–08. Stone, 11" (28 cm.). Muzeul de artă, Craiova. (Photo: Author)

2. Constantin Brancusi. *The Prayer*, 1907. Bronze, 43^{7}/$_{8}$" (111.4 cm.). Muzeul de artă R. S. R., Bucharest. (Photo: Author)

3. A pointing machine.

4. Constantin Brancusi. *Première pierre directe*, 1907. Stone. Whereabouts unknown.

5–10. Constantin Brancusi. *The Kiss*, 1907–08. (Photos: Author)

11. Relief, c. second century B.C., from Osuna, Spain. Museo Arqueológico Nacional, Madrid. (Photo: Museo)

12. Capital, twelfth century. Basel Groszmünster.

13. Giotto. *The Meeting at the Golden Gate*, detail. The Arena Chapel, Padua. (Photo: Alinari)

14. Giotto. *The Betrayal of Christ*, detail. The Arena Chapel, Padua. (Photo: Alinari)

15. Ashanti goldweight. From R. Rasmussen, *Art nègre*, Paris 1951.

16. Bolivian love charm. (Photo: Sloman)

17. Auguste Rodin. *The Kiss*, 1888. Musée Rodin, Paris. (Photo: Bulloz)

18. Jules Dalou. *The Kiss*. (Photo: Giraudon)

19. M. L. Béguine. *The Embrace,* Salon of 1906.

20. Peter Behrens. *The Kiss,* 1898. Private collection.

21. Edvard Munch. *The Kiss,* 1895. Private collection.

22. Pablo Picasso. *Lovers in the Street,* 1900. Private collection.

23. Pablo Picasso. *The Embrace,* 1900. Whereabouts unknown.

24. *The Kiss* (sculptor unknown). La Ruche, Paris. (Photo: Lélio)

25. Felix Voulot. *Le Pardon,* Salon of 1905.

26. R. C. Peyre. *Tendresse,* Salon of 1906.

27. Emile Derré. *Chapiteau des Baisers,* 1899.

28. Emile Derré. *La Grotte d'Amour,* 1905. From *Art et Décoration,* July–December, 1905.

29. André Derain. *Crouching Figure,* 1907. Museum des 20, Jahrhunderts, Vienna. (Photo: Museum)

30. Henri Matisse. *Music* (*Study*), 1907. The Museum of Modern Art, New York. (Photo: Museum)

31. Constantin Brancusi. *La Sagesse,* 1908. Stone, 19⁷/₈″ (50.5 cm.). Muzeul de artă R. S. R., Bucharest. (Photo: Mates and Katz, courtesy The Solomon R. Guggenheim Museum)

32. Constantin Brancusi. *Double Caryatid,* c. 1908. Stone, 29¹/₂″ (75 cm.). The Museum of Modern Art, New York. (Photo: Museum)

33. Henri Matisse. *The Game of Bowls,* 1908. The Hermitage, Leningrad. (Photo: Museum)

34. Henri Matisse. *Music,* 1910. The Hermitage, Leningrad. (Photo: Museum)

35. Brancusi's studio, 54 Rue du Montparnasse, 1907. Detail of a photograph. (Photo: Musée National d'Art Moderne, Centres Georges Pompidou)

36. Paul Gauguin. *Hina and Te Fatou,* c. 1893. Collection Mme. Huc de Monfriéd, Paris.

37. Brancusi's studio, 5 Place de la Bourse, 1905. (Photo: Brezianu)

38. Detail of studio showing "The Rebuff," 1905, by Brancusi.

39–40. Constantin Brancusi. *The Kiss,* c. 1908. Stone, 12¹/₂″ (31.7 cm.). Collection Mr. and Mrs. Harold Diamond, New York. (Photos: Author)

41–42. Constantin Brancusi. *The Kiss,* 1909. Stone, 35¼" (89.5 cm.). Montparnasse Cemetery, Paris. (Photos: Author)

43. Constantin Brancusi. *The Kiss,* 1912. Stone, 23" (58.4 cm.). The Arensberg Collection, Philadelphia Museum of Art. (Photo: Author)

44. Part of a letter from Brancusi to Walter Pach, October 4, 1916. The John Quinn Memorial Collection, New York Public Library. (Photo: Library, courtesy Dr. Pascu Atanasiu, Paris)

45. Constantin Brancusi. *Column of the Kiss,* 1916–18. Plaster, whereabouts unknown. (Photo: Musée National d'Art Moderne, Centres Georges Pompidou)

46. (a) Musée du Luxembourg, Paris, c. 1910. (b) Cooper Union Building, 1859.

47. Constantin Brancusi. *The Studio,* c. 1918. Ink on paper, 16¾ × 13⅞" (42.5 × 35.3 cm.). Collection Mrs. Gilbert W. Chapman, New York.

48. Constantin Brancusi. *Study,* c. 1917–18. Ink on paper, 16½ × 10¾" (41.8 × 27.5 cm.). Brancusi Bequest, Musée National d'Art Moderne, Centres Georges Pompidou, Paris. (Photo: Musée)

49. Constantin Brancusi. *The Kiss,* c. 1919. Plaster, c. 88" (223.5 cm.). This illustration is a composite of details of photographs which appeared in *This Quarter,* no. 1, 1925, and *The Little Review,* Autumn 1921.

50. Constantin Brancusi. *Medallion,* c. 1919. Volcanic stone, with iron rings, 23⅜" (59.5 cm.). Brancusi Studio, Musée National d'Art Moderne, Centres Georges Pompidou, Paris. (Photo: Author)

51. Constantin Brancusi. *The Kiss,* 1923–25. Brown stone, 14⅜ (36.5 cm.). Brancusi Studio, Musée National d'Art Moderne, Centres Georges Pompidou, Paris. (Photo: Musée)

52. Constantin Brancusi. *Mlle. Pogany,* 1919. Plaster, 17¼" (44.0 cm.), on a stone base, height 7⅝" (19.5 cm.). Brancusi Studio, Musée National d'Art Moderne, Centres Georges Pompidou, Paris. (Photo: Musée)

53. Constantin Brancusi. *The Kiss,* 1926. Ink drawing on an exhibition catalogue. Collection Tarsila do Amaral, São Paulo. (Photo: A. Amaral)

54. Constantin Brancusi. A calling card, 1937. Ink, $4'' \times 2^5/8''$ (10×6.5 cm.). Collection Mme. Colomba Voronca, Paris.

55. Constantin Brancusi. *Column of the Kiss,* c. 1930. Plaster, 9' 10" (300 cm.). Brancusi Studio, Musée National d'Art Moderne, Centres Georges Pompidou, Paris. (Photo: Sunami)

56. Emile Derré. *Chapiteau des Baisers,* 1906. Jardin du Luxembourg, Paris. (Photo: Service de documentation photographique)

57–58. Constantin Brancusi. *Model of the Gate of the Kiss,* 1935–37. Plaster, $20^7/8''$ (53.0 cm.); dispersed. (Photos: Musée National d'Art Moderne, Centres Georges Pompidou, Paris.)

59. Constantin Brancusi. *Gate of the Kiss,* 1938. Side view; see below.

60. Constantin Brancusi. *Gate of the Kiss,* 1938. Stone, $17'\ 3^1/2'' \times 21'\ 7^1/8'' \times 6'\ 1^1/2''$ ($5.27 \times 6.58 \times 1.84$ m.). Public Park, Tîrgu Jiu, Rumania.

61. Constantin Brancusi. *The Kiss,* early 1940s. Yellow stone, $28^1/4''$ (71.8 cm.). Brancusi Studio, Musée National d'Art Moderne, Centres Georges Pompidou, Paris. (Photo: Author)

62. Constantin Brancusi. *Boundary Marker,* 1945. Stone, $72^3/4''$ (184.8 cm.). Brancusi Studio, Musée National d'Art Moderne, Centres Georges Pompidou, Paris. (Photo: Author)

63. Constantin Brancusi. *The Kiss,* date unknown. Painted on an egg. The Lydia and Harry L. Winston Collection (Dr. and Mrs. Barnett Malbin, New York). (Photo: Joseph Klima)

64. Caricature of *The Kiss* by E. E. Cummings. From *Vanity Fair,* March 1927, 76.

65. Julio Gonzalez. *The Kiss,* 1930. The Lydia and Harry L. Winston Collection (Dr. and Mrs. Barnett Malbin, New York).

66. Constantin Brancusi. *Sleeping Muse,* 1909–11. Marble. 11" long (28 cm.). Hirschhorn Collection.

Index

Page references in italic refer to illustrations.

111